MUFFLER
MEN

Folk Art and Artists Series
Michael Owen Jones
General Editor

Books in this series focus on the work of informally trained or self-taught artists root-
ed in regional, occupational, ethnic, racial, or gender-specific traditions. Authors
explore the influence of artists' experiences and aesthetic values upon the art they
create, the process of creation, and the cultural traditions that served as inspiration or
personal resource. The wide range of art forms featured in this series reveals the
importance of aesthetic expression in our daily lives and gives striking testimony to the
richness and vitality of art and tradition in the modern world.

TIMOTHY CORRIGAN CORRELL
and PATRICK ARTHUR POLK

University Press of Mississippi
Jackson

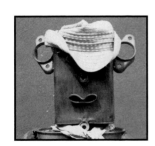

MUFFLER MEN

Also in this series

Illustration and photo credits: Frank Afra, figures 48 and 52; Veronica Buckingham, figure 71; Kevin Doyle, figures 41, 53, 56, 58, 66, plates 11, 18, 20, 22, and 23; Mike Hammond, figures 28, 39, 55 and 75; Laurel Horton, figures 59 and 60, plates 13 and 21; Dan Ruebbelke, figure 1; all other photographs by the authors.

www.upress.state.ms.us

Designed by Todd Lape

08 07 06 05 04 03 02 01 00 4 3 2 1

∞

Library of Congress Cataloging-in-Publication Data

Correll, Timothy Corrigan.
 Muffler men / Timothy Corrigan Correll and Patrick Arthur Polk.
 p. cm. — (Folk art and artists series)
 Includes bibliographical references.
 ISBN 1-57806-298-5 (cloth : alk.paper) — ISBN 1-57806-299-3 (pbk. : alk.paper)
 1. Muffler art—United States. 2. Folk art—United States. 3. Metal sculpture, American.
I. Polk, Patrick Arthur. II. Title. III. Series.

NK8459.M8 C67 2000
745.58'4—dc21 00-027338

British Library Cataloging-in-Publication Data available

This book is dedicated
to the repairmen
whose creativity
enlivens our roadsides

CONTENTS

PREFACE

On almost every day of the week for the better part of three
years, vehicles traveling in the busy northbound lanes of La Brea
Boulevard in West Los Angeles would regularly slow almost to a
crawl as they passed by the front of an automotive repair shop
bearing the name Affordable Muffler and Auto Repair. As if rub-
bernecking at the scene of a traffic accident or gawking at the
sights on Hollywood Boulevard, drivers would suddenly decrease
their speed and then roll by, peering inquisitively in the direction
of the sidewalk. Passengers in the cars or trucks often pointed or
waved; sometimes motorists even pulled over and stopped. Yet
there was never any wreckage to be seen nor any movie stars to
photograph. So what was it that consistently prompted drivers to
hit their brakes? Muffler men: brightly painted metal sculptures
crafted from used mufflers and other damaged automotive parts.

Each morning at rush hour, workers at the shop would drag out
as many as a dozen fantastic welded mannequins and carefully
arrange them in front of the business, knowing full well the effect
they would have on traffic (plate 1). Over the years, muffler sculp-
tures displayed at the garage depicted a wide range of icons from
American folklore and pop culture, including prizefighters, cowboys,

a baseball player, and the cartoon character Gumby. Like many other passersby, we were captivated by the assemblage. While working on a research project that took us to many different parts of Southern California, we had noted similar anthropomorphic and zoomorphic muffler figures at other garages. It wasn't until we happened upon the ever-changing lineup of statues at Affordable Muffler, however, that we decided to study the phenomenon more closely. After spending countless hours driving around the greater Los Angeles area actively seeking out muffler art, we found the custom of displaying such signage to be pervasive and were amazed by the wondrous array of forms we encountered. Reports from colleagues and friends elsewhere alerted us to the fact that muffler sculptures can be found throughout the United States as well as in many other parts of the world.

As we began to interview mechanics, we were intrigued by the meanings the metallic creations held for artists and viewers alike. In this book we attempt to convey some of that significance. We explore how these sculptures are inscribed with meaning based on the differentiated identities, circumstances, and motivations of particular artists (Bronner 1986: 216; Jones n.d.: 14). Furthermore, we seek to understand how sculptures accumulate additional and often unforeseen relevance through the day-to-day events and social interactions that occur at the work environments where they are displayed. While some of the repairmen we interviewed were genuinely surprised by our interest in muffler men, others were obviously used to receiving attention for their works and had already been visited by journalists, art collectors, and tourists. We hope this study will impart some of the visual richness that we have been lucky enough to experience firsthand.

This volume came into being largely as a result of the thoughtful advice and constant encouragement of Michael Owen Jones; his scholarship and the folklore courses he has taught at UCLA inform this study. We would also like to thank Archie Green, whose enthusiastic correspondences on "tin men" and other metal figures invigorated our own research. We are similarly indebted to

Laurel Horton, who made editorial comments on an early draft of this work and provided us with photographs and background information about the muffler assemblages she is documenting in her own community. Lynn Hadley helpfully pointed us in the direction of Melody Muffler & Lube Center in Walla Walla, Washington. Our muffler research has been greatly enhanced by the assistance of Doran Ross and the staff of the UCLA Fowler Museum of Cultural History. We would also like to thank Craig Gill of the University Press of Mississippi; his heroic efforts helped make this book a reality. We are indebted to the anonymous reader who made many useful suggestions for revising our initial draft of the volume. The UCLA Folklore and Mythology Archives and the UCLA Graduate Division Summer RA/Mentorship Program provided financial support that helped facilitate this study. We are particularly grateful to the many makers of muffler art who took time out to talk with us about their constructions. We want especially to thank Anna Suranyi and Jeri Bernadette Williams for their patience and understanding support during our lengthy and sometimes feverish bout with muffler madness.

MUFFLER MEN

CHAPTER 1

ART IN THE WORKPLACE

Occupational settings provide dynamic and greatly rewarding contexts for the study of traditional expressive forms, processes, and behaviors that may appropriately be termed folklore. Members of occupational groups often recite specific kinds of work-related stories (Santino 1978; Mullen 1978; Tangherlini 1998), share common terminology or slang (Jones 1967; Bennett 1969), and employ technical skills passed on through face-to-face interaction (McCarl 1974; Evans 1998). These behaviors may be used to carry out work tasks, construct notions of identity, establish social hierarchies, ameliorate anxieties, and help relieve the monotony that all too often defines the workaday world.

3

Material endeavors are a common means of aestheticizing the workplace and imparting meaning to daily routines. As C. Kurt Dewhurst has noted, "The aesthetic operatives in the work setting include not only the performance of occupation, the playification of work, the verbal and behavioral traditions associated with work, but also the manipulation of work material and physical work environments. This manipulation includes the creation of objects for pleasure and sale from the materials of work, in addition to the alteration of the physical environment in which work takes place" (1984: 193). Throughout the world, workers employed in various occupations use the by-products of their labor as raw materials for artistic expression. A notable historical example of an occupation-based folk art tradition is the practice of scrimshaw carving engaged in by whalers during the eighteenth and nineteenth centuries. Whether serving aboard vessels working the North Atlantic or the South Pacific, seamen customarily transformed bits of whalebone into intricately detailed works of art. While the fabrication of scrimshaw was certainly not central to a sailor's occupational duties, the practice nonetheless became an important component of maritime culture.

During the twentieth century, many forms of occupational creativity have been documented in the United States. For nearly one hundred years, craftsmen engaged in the manufacture of industrial sewer and drain tile in Grand Ledge, Michigan, have sculpted animal-shaped bookends, ashtrays, and money banks out of spare materials (Dewhurst and MacDowell 1980). Similarly, employees at a General Motors plant in Lansing, Michigan, routinely "catch the excess drippings of car paints and finishes on pieces of metal to make into jewelry for wives, daughters and friends" (Dewhurst 1984: 196). Workers in a western sawmill use pens and pencils to decorate knots cut from lumber and then send the artworks down the assembly line in order to entertain other employees (Brunvand 1986: 428). The more recent practice engaged in by computer engineers of etching images of cheetahs, Egyptian gods, and college mascots onto microprocessor chips may also be understood as artistic play in the workplace (*Molecular Expressions: The Silicon Zoo* 1998).

Vocations that require welding, fabricating, and other types of

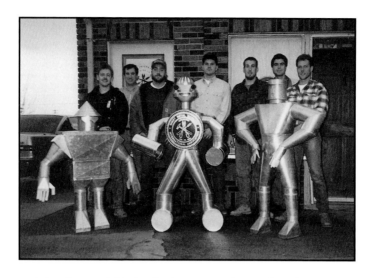

metalwork are notable for the imaginative forms of art that are manufactured on the job. Ron Thiesse created a series of animal figures using excess titanium he collected while working at an aircraft assembly plant (Nickerson 1978). In order to combat the mind-numbing monotony of assembly-line work, an anonymous production welder at an automobile factory in Michigan used spare parts and pieces of metal to sculpt small creatures with crinkly hair and rumpled hides (Lockwood 1984: 202). Charles Julian, a "loose-work molder" employed at a Detroit area foundry, experimented with bronze castings as a means of competing with his fellow workers and to amuse family members (Dewhurst 1988: 247). Exemplifying a form of artistic expression enacted by individuals united by occupation but employed at different work locations is the construction of "tin men" by laborers in the sheet metal industry. Since at least the 1930s, these metallic humanoid figures have served as a way for workers to practice and demonstrate skills, as advertisements for business locations, and as emblems for local trade union chapters (Green and Airulla 1996; Green 1999) (fig. 1).

Figure 1. "Tin Men." Joint Apprentice Committee of Local 29, Sheet Metal Workers' International Association, Wichita, Kansas.

Because automotive mechanics specializing in the installation and repair of exhaust systems work extensively with

metal parts, bending machines, and welding equipment, they, too, possess the skills, tools, and materials that, with a little artistic inspiration, are used to craft decorative or symbolic objects. The extent to which muffler repairmen engage in the fabrication of art in the workplace is highlighted by Dan Hull, a Midas Muffler representative, who states, "Just find a tech with a MIG welder and some scrap metal and you've got a dangerous combination." We have, in fact, encountered a wide range of imaginative creations—ashtrays, religious shrines, furniture, toys—in the many shops we have visited. Muffler sculptures depicting humans and animals, however, are the most common forms fashioned by automotive repairmen. This is not surprising, given that the appendage-like pipes and torso-like exhaust chambers of the used mufflers that accumulate in repair shops readily suggest living creatures.

Commonly referred to as "muffler men" in English and *muñecos* (dolls or puppets) in Spanish, these creations are primarily used to advertise in a signature fashion the availability of muffler repair service (fig. 2; plate 2). Hundreds, if not thousands, of muffler figures exist throughout the United States. We have encountered more than 150 in the Los Angeles area alone and have additional documentation of examples in Arizona, Arkansas, Florida, Georgia, Iowa, Mississippi, Missouri, New Mexico, New York, South Carolina, Tennessee, Texas, and Washington State. We have also received reports of the existence of sculptures in such diverse locations as Brazil, El Salvador, Guatemala, Holland, Mexico, Senegal, South Africa, and Spain. In all likelihood, they can be found anywhere in the world where automobiles are common.

Despite the widespread use of muffler sculptures as an occupational art form, the history of the tradition has been difficult to document. One reason is that few repair shops have been under the same management, or even in the same location, for more than twenty years. Up until the 1970s, most muffler shops were small individually owned operations that were likely to close down when their proprietors

Figure 2. Muffler man. José Cortez. José's Auto Service, Inglewood, California.

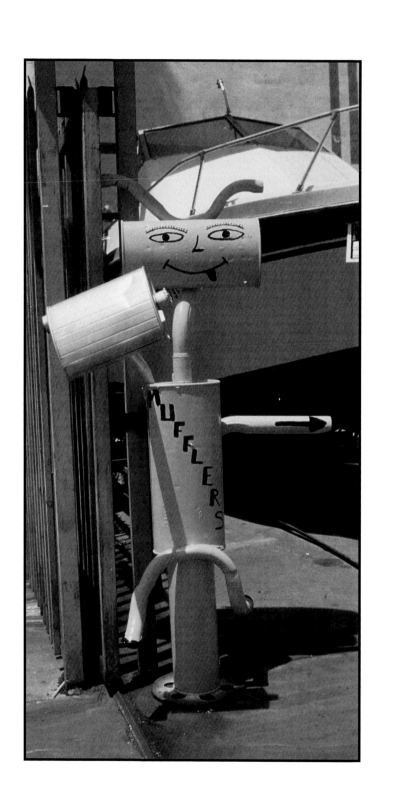

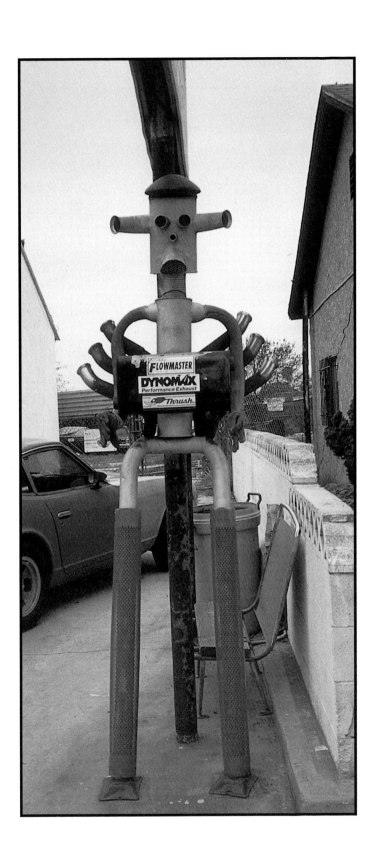

retired, passed away, or changed vocations. As a result, the workplace environments where sculptures are found tend to disappear from public view and communal memory after one or two generations. Thus, tangible data concerning muffler art rarely dates back more than two or three decades. The fact that the sculptures, although constructed from metal, are perishable presents an additional obstacle in documenting the history of muffler art. Vandalism and natural deterioration such as rusting take a toll on the figures. Without continual observance and upkeep, the sculptures literally fall apart.

Of the numerous informants interviewed in our study, only one, Joe Loria of Carson Muffler in Carson, California, recollected the utilization of sculpted muffler signage before the 1960s. Loria reports that he had built a robot-like muffler man when his shop first opened for business in 1957, but does not recall having seen any sculptures earlier than that (fig. 3). He says, "I think back then, I don't think there were any. There could have been, but I didn't know it." Loria suggests that his statue was more likely influenced by the imaginative ways in which other business proprietors had used surplus military items to create unique forms of advertisement (fig. 4). As evidence of this, Joe noted that his figure originally had an authentic World War I military helmet welded onto its head.

We have been told numerous times that muffler sculptures

Figure 3. Robot. Joe Loria. Carson Muffler, Carson, California.

Figure 4. Storefront signage using surplus military ordnance. Miranda's Auto Repair & Tires, Los Angeles, California.

were commonplace at repair shops during the 1960s and that, by the 1970s, they had emerged as a widespread phenomenon. Speaking of the greater Los Angeles area, Joe Loria states that "in '70, '75, everybody had one in front of their shop." Similarly, Gary Koppenhaver of G & R Mufflers in Lake Elsinore, California, says, "I knew most muffler shops had a muffler man. I think everybody made one back then." While reflecting on the prevalence of muffler art during that decade, Loria additionally commented that "there's nothing like it nowadays." Other repairmen have likewise suggested that the art form enjoyed its greatest level of popularity during the 1970s. Among the several mechanics who told us they used to fashion muffler sculptures but no longer do so, one even termed the tradition "old-fashioned." Others asserted that they simply "don't have the time" or are "too busy" to create new figures.

The perception that muffler sculptures are less popular today than they were several decades ago may, in part, be a consequence of the steady shift away from individually or family owned businesses to larger chains of automotive repair franchises with nationwide distribution. Shop managers who must report to corporate offices are undoubtedly less likely to authorize the construction of such objects than are their counterparts at independent garages. Furthermore, franchisees have to comply with corporate regulations outlining the types of signage and decor that are allowed. Little leeway is left for the manufacture and use of hand-crafted embellishments. The Midas representative Dan Hull informed us that while franchisees are not officially prohibited from creating muffler art, the production of such "kitsch" is generally discouraged. Not surprisingly, almost all of the sculptures we have documented were found at smaller privately owned businesses. It should be noted, however, that even some of the independent shop owners disapprove of muffler sculptures because they feel the objects project a sloppy and unprofessional image.

Despite the fact that some repairmen believe that muffler sculptures are no longer as plentiful as they once were, our research indicates that the art form remains a vibrant, if not expanding, occupational tradition. Such artworks are especially prevalent in the burgeoning Latino communities of the southwestern United States,

and, accordingly, some scholars have related the behavior to a Latino cultural aesthetic of recycling and reuse (Graham 1991; Turner 1996). In predominantly Latino sections of Los Angeles, for instance, one can often find repair shops displaying muffler figures within one or two city blocks of each other. For exhaust mechanics and others in these neighborhoods, the creation of muffler sculptures is a

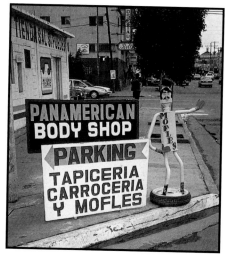

normal if not expected behavior. Gus Lizarde of Lizarde Auto Service asserted that the figures function iconically for many of his customers, saying, "The ones from Latin America, if they see them outside they know we do muffler repairs." Because *muñecos* are commonplace in Latino communities in the United States as well as in Mexico and Central America (fig. 5), a number of Latino repairmen readily identify the tradition as part of their ethnic heritage.

Many of the muffler sculptors we interviewed, however, do not consider the practice to be an ethnic tradition. Joe Loria, who is an Italian-American, was surprised to hear that the objects seem to be more prevalent at Latino businesses than elsewhere. For him and others, the construction of muffler sculptures is an endeavor that expresses and elaborates professional rather than cultural identity. Here, Miles Richardson's assertions that "material culture orders our world into discrete social places," and that "[e]ach social place has attached to it a distinctive set of concepts and a distinctive array of behavioral elements" are applicable (1974: 7–8). More simply put, many automotive repairmen and their clients believe that muffler shops should have muffler men.

Figure 5. Muñeco (muffler man) and other signage. Panamerican Body Shop, Tijuana, Mexico.

CHAPTER 2

FROM ADVERTISEMENT TO OCCUPATIONAL TRADITION

Advertising and the internal combustion engine are, according to the French modernist poet Blaise Cendrars, two of the seven marvels of the modern world (cited in Smith 1993: 49). The highways and byways of America offer ample support of his assertion. They are literally lined with banners, billboards, and innumerable signs vying for the attention of those passing by, who are usually in automobiles. Cityscapes are replete with customized storefronts that draw attention to the type of business within as well as projecting a unique sense of character (Kim 1997; Baeder 1996). Rural areas, or at least the paths through them, are similarly adorned (Cantrell 1998). Travelers who toured America during the 1950s and 1960s

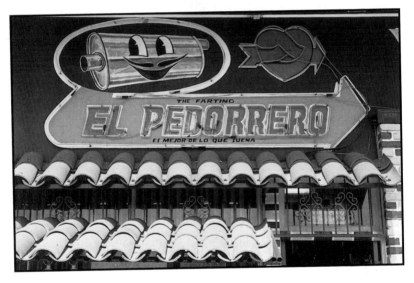

Figure 6. Mural. Jack's Muffler Service #2, Bell, California.

Figure 7. Shop mural with a smiling muffler. El Pedorrero Muffler Shop, East Los Angeles, California.

Figure 8. Storefront sign featuring an airbrushed depiction of a muffler man. Serrano Tires & Muffler Shop, Los Angeles, California.

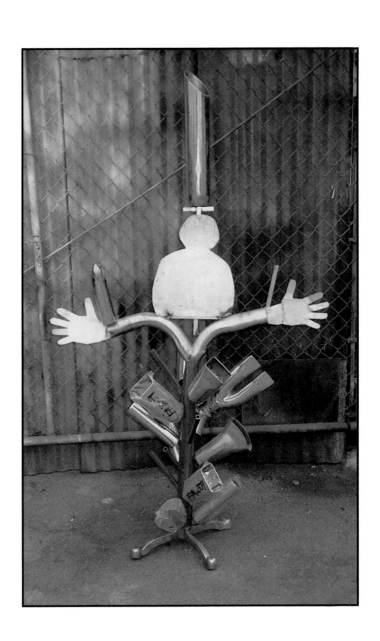

probably have more vivid recollections of the catchy rhymes posted on Burma Shave signs than of some portions of the landscape they crossed.

Like the proprietors of other retail and service-oriented businesses, the owners of muffler repair shops frequently decorate their signs, business cards, and print advertisements with stylized renditions of the so-called "funny little man" graphic logo that has been a predominant image in twentieth-century American and European commercial art (Smith 1993) (fig. 6). The funny little men found on automobile shop signs readily become funny little anthropomorphic mufflers (figs. 7, 8) and it is an easy transition from two-dimensional figures to three-dimensional sculptures. These, along with other idiosyncratic forms, are more likely to stand out among the abundance of advertising signage and visual clutter that sometimes overwhelms the senses of onlookers (figs. 9, 10).

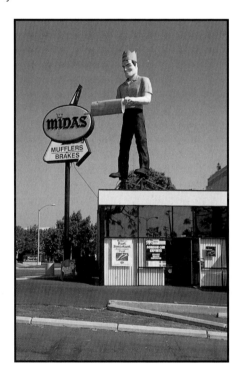

Like other forms of advertisement, muffler art is pragmatically driven in that the sculptures are primarily used as a means of attracting customers. Time and again, repairmen emphasize their belief in the value of the sculptures as promotional gimmicks, saying they are "attractions" and "attention-getters." As the mechanic Joe Loria puts it, "It's just an eye-catcher and that's what you need. . . . Look at all the signs; signs everywhere. Hell, you don't even look at them. There's so many after a

Figure 9. Anthropomorphic exhaust tip "tree." Frank Duron, Jr. Frank's Welding, Los Angeles, California.

Figure 10. Giant fiberglass muffler man. Midas Muffler, Whittier, California.

while, you just drive by, but if you see something like this [muffler man]. . . . "

By the mere fact of their existence, muffler sculptures metonymically announce the presence of muffler repairmen. In this way, they are akin to other traditional forms of commercial signage such as barber poles and wooden cigar-store Indians. Who else but exhaust system mechanics would have access to used mufflers and possess the necessary welding skills to turn them into works of art? And who else would want to do so? As Francis Mohsen of Quality #1 Auto Repair in Los Angeles remarks, "I had to tell people that I'm doing mufflers, so that's why I stuck the [muffler] man outside. . . . Most auto repairs don't do mufflers, you have to go to an 'only muffler' shop. So we let people know. . . . Just about every muffler shop has to [pointing to the words printed on the sign in front of his shop]. 'Auto Repairs,' they'll never know. . . . The best attraction to the human eye is the [muffler] man and you know these people, they do mufflers." Additionally, sculptures often have product decals and the standard cost of repairs painted on them (fig. 11). Shop owners may also use the figures to promote other types of services. Some mechanics, for instance, have built muffler men holding up radiators or the latest styles in chrome exhaust tips.

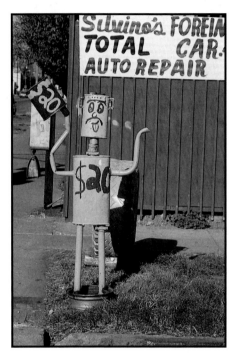

Figure 11. Sculpture featuring repair prices. Isidro Hernandez. Azteca Tire and Muffler, Los Angeles, California.

Muffler sculptures are particularly useful for marking the location of shops that are otherwise difficult to see from the road.

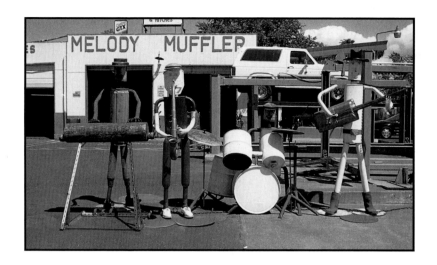

Concerning his first muffler creation, Gary Koppenhaver says, "I made it more for advertising. I was back in a wrecking yard way off the street, so I wanted to put some stuff out there." A statue can also help repairmen provide customers with directions on how to find their shop. Describing the effectiveness of this strategy, Salvador Martinez of Hot Shot Mufflers in Los Angeles states, "This is the only way that people know we are here. We are in the middle of the block and people usually go by. So I just tell them, 'Look for the statue right there and you'll find it.'"

Based in part on the principle that the more sculptures one puts on display the more likely it is that passing traffic will take notice, many repair shops exhibit multiple muffler creations (fig. 12). Business owners usually place these on different sides of the location or at different levels—one on the ground and another on the roof or affixed to a pole. This way, passersby have a better chance of seeing at least one of the sculpted signs. A few mechanics have made double-sided figures so that the decorative features can be viewed by people traveling in either direction on a two-way street.

Figure 12. Muffler musicians created by Mike Hammond. Melody Muffler & Lube Center, Walla Walla, Washington. Mike jokingly refers to the assembly as a "heavy metal" band.

At some shops, crowds of muffler creatures accumulate over time as mechanics craft

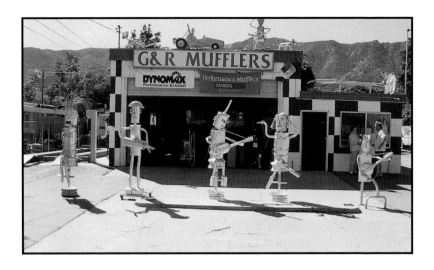

new promotional figures and place them alongside preexisting ones. Describing how the collection of sculptures displayed at one of the muffler repair businesses he owns began, Kevin Doyle of Mad Hatter Muffler in Hollywood, Florida, says, "When we first opened our Miami shop, we started out with just trying to get a little attention, so we made a little muffler guy like a lot of the shops do, and we dragged him in and out every night. . . . And one guy led to another and led to another and I kept putting them out there until we had a small menagerie." At Affordable Muffler and Auto Repair in Los Angeles, Frank Afra routinely stationed multiple sculptures in front of his garage. Asked if he thought they attracted customers, Afra declared, "They're bringing business, people are seeing them, they're bringing business. . . . Oh, you won't believe when I had about fifteen of them sitting out there . . . and all these people—I had so much business, I stopped advertising." Gary Koppenhaver, who displays a dozen muffler sculptures at his shop, likewise states,

Figure 13. Storefront display featuring muffler sculptures by Gary Koppenhaver and Duncan Turrentine. G & R Mufflers, Lake Elsinore, California.

"I think it's great advertising. People stop in all the time. They always go out and look at them." Gary further notes, "Twelve years ago when I first came here, it was something new for people. So a lot of people were stopping by with their kids" (fig. 13).

Sometimes repairmen further promote their businesses by festooning vehicles with numerous stickers, decals, and even murals advertising both their shops and the products they stock. Occasionally, these mobile signboards become so highly decorated that they may be categorized as works of art in and of themselves. Using bright paint, old mufflers, and a giant truck tire, Bill London, proprietor of El Pedorrero Muffler Service in East Los Angeles, created an eye-catching sign that he parks on the street in front of his business each day in order to attract customers. Likewise, Mike Hammond of Melody Muffler & Lube Center in Walla Walla, Washington, turned an old Plymouth Volari into an "art car" complete with flashy murals and numerous muffler sculptures welded to its roof, hood, and trunk (plates 3–5). Hammond enjoys driving the vehicle around town and watching people's reactions as he passes by.

Among repairmen, the creation of muffler art often functions as an important act of occupational identity. A number of mechanics—some of whom report having seen muffler sculptures since childhood—explicitly stated that one of the most influential factors in their decision to construct muffler men was the fact that they observed statues at other muffler shops. Jessie Tarula of Azteca Tire and Muffler in Los Angeles, for instance, points out that he has made several sculptures, not so much for advertisement but because "everyone around here does it." Francis Mohsen similarly notes that "just about every muffler shop has its own unique muffler man." Thus, occupational tradition provides the motivation and the conceptual framework whereby artistic expression can flourish.

While muffler sculptures may help repairmen proclaim membership in a collective social category, they can also inspire competition among sculptors working at different shops. As Francis Mohsen says, "Everybody also takes the challenge of who is going to have the best-looking [one] . . . which one attracts [customers] more." Repairmen frequently express pride in the artistic and technical merits of their own sculptures as compared to those fashioned by competitors. Describing the workmanship of the muffler sculpture a neighboring shop put on display after his own creations had achieved local acclaim, Kevin Doyle states, "These guys put it up and it's half welded and half put together. There's no care in it. They stuck something out, 'Look, I got one, too.' It's not nice looking.

It looks good from the street at fifty miles an hour, or it looks nice if you're a one-eyed man on a fast horse on a rainy night. But when you get out and walk around and look at the stuff, you just get back in your car and you leave."

Voicing a similar sentiment but in a more direct manner, Kal Mekkawi of Affordable Muffler and Auto Repair cited other muffler sculptures located in the vicinity of his business and declared, "We make the best, nobody makes them like ours."

Because exhaust repairmen closely associate the creation of muffler sculptures with their professional identity, the assembly of a sculpture often functions as a rite of passage in "its use of the natural work context in an expressive, symbolic manner to mark transitions" (McCarl 1978: 157). Among other things, the construction of a muffler man may delineate a new worker's transition from outsider to insider status through incorporation into creative workplace activities, the movement of skilled repairmen from shop to shop as they change places of employment, or an individual's progression from employee to shop owner through the founding of a new business.

New workers at shops that display muffler men often express a desire to join in the making of a sculpture or even to try their hand at constructing a figure of their own. Such participation helps new employees to become better integrated into the social fabric of the workplace by enabling them to develop a closer sense of camaraderie with their coworkers. Francisco Solis, for example, fondly reminisces about a giant muffler figure he helped build when he was apprenticed at a repair shop in Guatemala City, Guatemala. Once completed, such works may be displayed along with the pre-existing sculptures, thus marking the initiation of a novice repairman into both the workplace and the occupational tradition. Conversely, as we have found at several garages, the removal or deterioration of a figure may mark a worker's departure from a shop.

In the highly competitive exhaust system business, mechanics

Figure 14. Space alien with baby. Miguel Gutierrez. AAA Mufflers and Radiators, Los Angeles, California.

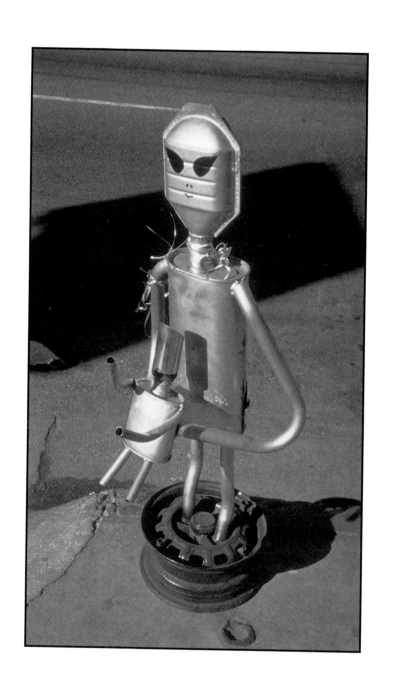

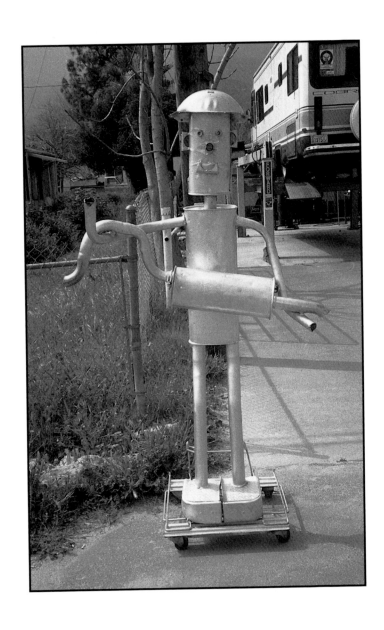

routinely change their places of employment as shops open and close or better salaries are offered. A number of muffler sculptors said that they like to fashion a sculpture when they move on to a new work location. Francisco Solis of Lizarde Auto Service in Los Angeles, for example, has constructed muffler figures at a number of the different shops where he has been employed during his thirty-five years as a repairman. For him, the artworks symbolize both occupational continuity and personal change. Likewise, Miguel Gutierrez of AAA Mufflers and Radiators in Los Angeles told us that he has built sculptures (including a Pink Panther that is well known among local repairmen) at several locations in the area. When he started at his current place of employment, Miguel crafted a figure depicting an alien holding a chrome-headed baby (fig. 14). He then placed the new piece alongside a little blue-and-yellow *muñeco* that was already displayed at the shop.

Muffler sculptures frequently function as emblematic markers of the founding of a business. When Hector Isordia and his brother Jose first opened Arco Iris Muffler Shop in Eagle Rock, California, in the early 1990s, they inherited a sculpture that had been left behind by the previous owner of the garage. They kept the work, but Jose also crafted a new sculpture using parts the brothers had accumulated as a way of adding their own personal "signature" to the shop's facade. Wearing a bib and referred to as "the baby," the figure delineates the birth of their business. Kevin Doyle engaged in a similar

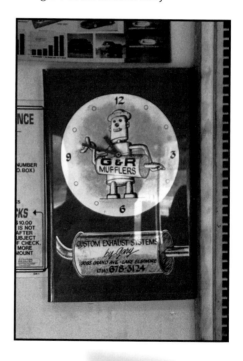

Figure 15. The G & R Muffler Man. Gary Koppenhaver. G & R Mufflers, Lake Elsinore, California.

Figure 16. Clock with muffler logo. G & R Mufflers, Lake Elsinore, California.

process when he opened a muffler repair shop in Hollywood, Florida. After constructing a new muffler sculpture for the location, Doyle incorporated the work into a playful advertising strategy involving a large wooden signboard left by the previous owner of the garage. Doyle notes, "[I] had a sign painter come out and paint a sign on it that said 'Coming Soon Mad Hatter.' And mostly you could read 'Coming Soon Mad Hatter' and then the word 'Muffler' was outlined. You could read it, but it wasn't painted in blue like the rest of the sign. I had him do it specifically that way 'cause I made a muffler guy and planted him out there along the street—made a big red muffler guy for this shop—and stuck a wallpaper brush in his hand because it's big and fat and slobbered blue paint all over him and all over the ground around him. It looked like he was painting the sign. So it stayed up for a good month and a half until after we opened, and then I took the brush out of his hand and we had the sign finished 'Now Open.'" In this case, the sculpture not only served as an iconic representation of the newly founded business, but also, in a tongue-in-cheek manner, was made to appear instrumental in the opening of the shop.

A muffler man displayed at Quality #1 Auto Repair in Los Angeles even more directly reflects how a sculpture can come to represent the moment when muffler repair work began at a new business. Describing the process by which he constructed the piece, Francis Mohsen says, "You take it from old pieces. Always. The unique part of the whole thing is just using some of your first mufflers. Yeah, and then your first pipes. You save those first things. You know how you save your first dollar in business, that's how we did it." Thus, the artwork literally embodies the activities that officially inaugurated the shop as a legitimate place of business and demonstrates the owner's membership in the exhaust repair profession. The symbolic recycling of materials in this way, as Barbara Kirshenblatt-Gimblett points out, serves as "a common method of embedding tangible fragments of the past in an object that reviews and recaptures the experience associated with those fragments" (1989b: 331).

Some self-employed muffler repairmen directly associate the creation of muffler sculptures with the feelings of professional self-determination and freedom they experienced as a result of the

transition from being an employee (and thus subject to a boss's whims) to being a business owner who may do as he pleases. Gary Koppenhaver, for example, made a muffler sculpture at the garage where he first worked, but the owner of the business frowned on the production of such objects and "didn't even want it in front of his shop." Describing that experience, Gary states, "I was running the shop for a guy named Tiny, Tiny's Muffler, and he got mad at me. He said, 'What are you doing?' I said, 'Making a muffler man for advertisement.' He said [inflected voice], 'Ah, that stuff's junk.' I go, 'No, no, this is art stuff man, ya know [laughter]. . . . ' Yeah, he thought I was wasting my time. He thought I should have been working. . . . He wanted me to concentrate on learning the shop instead of doing muffler people [laughs]."

Later, when Koppenhaver opened his own business, he made another muffler figure. Says Gary, "I thought, now I can make my own muffler man and nobody's going [laughing] to throw it away. I'm my own boss, I can do this if I want to." The first sculpture built by Gary Koppenhaver as an independent muffler repairman has become so intertwined with his occupational identity that he now uses it as his logo on business cards, customer receipts, and even his office clock (figs. 15, 16).

Other muffler artists echo Koppenhaver's experience. Kevin Doyle, for example, began making sculptures only after he established his own business. As an employee at other shops, he was deterred by the "you're not wasting our materials?" and "not on my time" accusations that can be leveled at employees who experiment with extracurricular artistic endeavors. Once he was self-employed, Doyle allowed himself "more freedom" and started to fashion muffler figures.

Mike Hammond professes a similar history. "I worked at another muffler shop and I wanted to make a muffler man at that point. The boss didn't like the idea, thought it would be too junky looking and wouldn't conform to his business. So fifteen years ago when I had my own shop, I had the opportunity to make my own." In keeping with a managerial approach quite different from that of his previous employer, Hammond asserts that his employees are encouraged to join in the tradition of playing with metal. "You don't want work to be boring so we have these skull welding hoods and

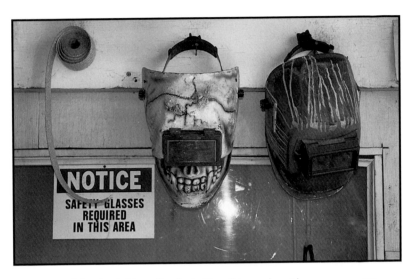

all kinds of things like that. One thing, when I became my own boss, I didn't want to be a slave driver and to have things boring, so I've let my crew kinda experiment and do fun things. And we have a stereo, and we turn it up and quite often you'll drive by we'll be in there dancing and whatever." As a result, some of the nearly three dozen pieces that adorn Hammond's shop were partially or completely designed by his employees (fig. 17). Thus, the assemblage expresses not just an individual artistic vision but a communal endeavor as well. Like scrapbooks containing treasured photographs or heirlooms proudly displayed on mantles, such collective creations are tangible embodiments of the shared experiences that unite coworkers.

Figure 17. Customized welding masks. Melody Muffler & Lube Center, Walla Walla, Washington.

CHAPTER 3

CREATIVITY AND THE CONSTRUCTION PROCESS

For the most part, automotive repairmen consider the creation of muffler art to be a leisure activity. At some garages, workers build numerous figures each year, while their counterparts at other shops fabricate only one or two new sculptures annually. Some owners are content with simply repainting or updating old figures once or twice a year. Concerning the construction of sculptures, Salvador Martinez, who has built five muffler men says, "We just do this when we don't have anything to do. . . . When we're not doing anything, we just kill time with it." Depending on the amount of free time they have as well as the accessibility of appropriate parts, muffler repairmen may spend anywhere from a few

Figure 18. Baseball player
sculpture in progress. Frank
Afra. Affordable Muffler and
Auto Repair, Los Angeles,
California.

Figure 19. Head of a muffler
woman (see also fig. 42).
Gary Koppenhaver and
Duncan Turrentine. G & R
Mufflers, Lake Elsinore,
California.

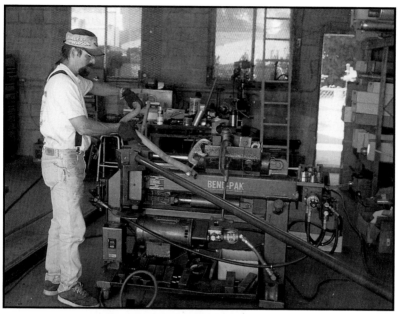

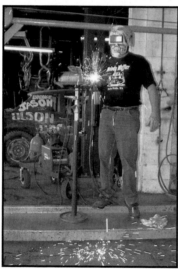

Figure 20. Gary Koppenhaver working at his pipe-bending machine. G & R Mufflers, Lake Elsinore, California.

Figure 21. Mike Hammond with welding torch. Melody Muffler & Lube Center, Walla Walla, Washington.

hours to days, weeks, or even months working on one sculpture (figs. 18, 19). As Mike Hammond points out, "If it's not busy at the shop and you can spend a lot of time on them, you get into a groove and you stick with it and in a couple of days you have one done. Others, if it's busy, you do a little bit here and there and then you come back to it. So some of them take a period of a month or so and others you can have done in a couple of days." Yasir Flores, who has built several dozen figures with his father, Salvador, notes that it usually takes about two and a half months to construct a figure. He states, "We do it little by little, whenever we have a chance, whenever we're not working, whenever we have the parts to do it."

To construct sculptures, muffler mechanics apply their full range of technical skills and most of the equipment that they employ in their vocation. They use blow torches to melt and cut pieces of sheet metal, pipe-cutting machines to section metal parts, grinders to smooth edges, hydraulic pipe-bending machines to shape exhaust pipes and other metal tubing into properly posed limbs (fig. 20), and arc or MIG welders to connect the various pieces (fig. 21). Many other workshop tools such as rubber

Figure 22. Francisco Solis with unfinished muñeco. Lizarde Auto Service, Los Angeles, California.

Figure 23. Shop worker spray-painting spots on muffler dog designed by Frank Afra. Affordable Muffler and Auto Repair, Los Angeles, California.

Figure 24. Yasir Flores with a finished sculpture. La Tortuga Auto Repair, Los Angeles, California.

Creativity and the Construction Process **32**

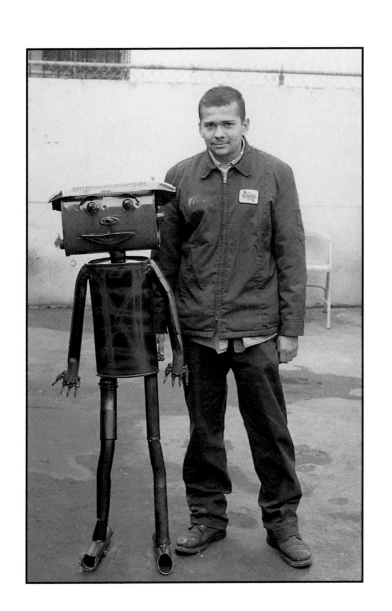

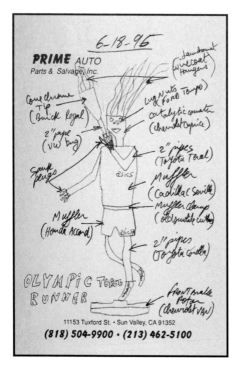

hammers, vices, tin snips, and pliers are also used by mechanics to apply, modify, and detail sculptural components.

The prototypical muffler man, or *muñeco*, has a muffler torso, exhaust-pipe limbs, and a catalytic converter head, but variation is the rule (fig. 22). The artists gradually bring the figures to life by adding more and more detail, and, when the sculptures are considered nearly complete, the makers typically spray-paint them, in some cases taping off sections that will receive different colors (figs. 23, 24). Facial features may be welded on with nuts, bolts, and other oddments, painted on, or drawn in with Magic Markers (plate 6). Workers at Lincoln AutoRepair and Muffler in Santa Monica, California, and Melody Muffler & Lube Center in Walla Walla, Washington, report using as artistic techniques skills acquired inadvertently during the removal and installation of mufflers. For example, they have learned to scorch unpainted metal with blowtorches in order to achieve patinas of various shades and colorings.

Before beginning construction, some muffler repairmen first sketch out designs for their sculptures. Frank Afra draws a plan, considers what parts will fit his design, and then labels the blueprint accordingly (fig. 25). To do so, he draws on a compendious knowledge of auto parts. Frank enjoys meticulously identifying the make and model of the car used for each part of his sculptures. Both literally and symbolically, the statues are

Figure 25. Design for an Olympic torch bearer (see also fig. 60). Frank Afra. Affordable Muffler and Auto Repair, Los Angeles, California.

microcosms of the repair work done at his shop. Once he has created a design, he waits for specific types of automobiles in order to acquire the components he needs. As time passes and more vehicles are serviced, he gathers the used parts that will enable him to finish the sculpture. Most mechanics, however, work in a more impromptu fashion. Salvador Martinez declares that he and his colleagues proceed more spontaneously: "We don't plan nothing, whatever comes into our minds we do it." Concerning a muffler cowboy that he and a colleague created, Salvador elaborates, "Well, he just comes into our minds. Well, you know, we start working out things and putting things together and we decided right there. We don't plan it or anything. We started to make it, and we decided to put a little muffler there, then hands and a sombrero."

While muffler art is often built during lulls between repair jobs, the ongoing construction of sculptures should not be seen as a process that is absolutely distinct from labor. Rather, it is a creative endeavor that evolves out of and transforms the work routine. The act of removing broken parts often suggests new designs for muffler sculptures. Damaged pieces are constantly being "reseen" and "reevaluated" through an artistic filter for use in creations (Greenfield 1984) (fig. 26). Yasir and Salvador Flores, for example, were inspired to build a miniature tank when they saw some timing chains that resembled the caterpillar tread propulsion system of a military vehicle. Yasir notes, "We decided to make it 'cause a friend took his engine apart, and in the engine there were some timing chains. So from those timing chains we decided we could make a tank. And we started making it little by little." Mike Hammond has experienced comparable

Figure 26. Blown-out muffler with curving pipe that inspired Frank Afra to create a series of muffler cat sculptures. Affordable Muffler and Auto Repair, Los Angeles, California.

moments of inspiration. Discussing a particular type of muffler that has a single inlet and dual outlets, he remarks, "[T]he single inlet looks like it would make a perfect neck and the body of it is a torso, and the dual outlet for the dual legs. Yeah, there are some things like that; you take them out and you go, 'Hey, I know what I can do with that one.'" Mike has noticed similar behavior among his employees: "Instead of just looking at something as an old used part to discard, they take a second look at it and say, 'Hey, you know this could be this.' I've noticed that they look at items now differently, rather than just a piece of scrap iron to throw away, I see them tilting their heads and looking at it."

The mounds of oddly shaped used parts that accumulate at repair shops also stimulate moments of artistic creation (fig. 27). Mike Hammond refers to scrap piles as "gold mines" and states, "[S]ometimes you'll just see an object and [say], 'Well, that looks like the torso of a pterodactyl or something.' So then I take that object and try to tie in other objects that work with it." Gary Koppenhaver remarks similarly, "When we're just walking around and not doing something, which is not too many times, but when we do, we just go to the [muffler] pile and stand there [looking]." Duncan Turrentine concurs: "You gotta see them, if you don't see them in the pile, you don't make them. You just gotta see 'em."

Figure 27. Used muffler pile. Affordable Muffler and Auto Repair, Los Angeles, California.

Whether proceeding from a conceptual plan that exists only in their minds or from a sketched

blueprint, muffler sculptors rely on creative spontaneity to deal with the exigencies of construction. As Charles and Janet Dixon Keller note concerning blacksmith work, there is a kind of playful duality involved in the process of construction consisting of an "internal, mental and external active side." Imaged goals are reorganized and creatively elaborated as the contingencies of construction are attended to and as "knowledge is brought to bear on problem solving" and aesthetic sensibilities come into play (1993:128–29). As Gary Koppenhaver points out, "When you start making it, you see stuff in your mind, and you go, 'Hey, that would look good.' And if it doesn't look good, you think of something else. . . . It's just kind of fun to make up, and you just keep going. It's kinda like making a cartoon on a piece of paper." He pointed out as an example the fact that he and his colleague Duncan Turrentine had spent a whole day working on a muffler woman's head to get it right: "We put probably seventy noses on her. . . . It just didn't come out right. I finally said, 'No, we just have to make something if we want a slender nose.'"

In some instances damaged parts may arrive that, although not specified in designs, prove ideal for certain pieces. Such was the case with a recreational vehicle break shoe that Frank Afra used for the helmet crest on a Trojan warrior he was building. As Frank recalls, "We had an RV, a recreation vehicle, and it had big break shoes. . . . When my mechanic took it out, I said, 'This is it, it's perfect for the helmet [laughter]!'" The shape of a piece may also suggest creative elaboration not originally conceived of or part of a design. When Frank was asked why there was an earring on the bloody-faced boxer he had created, he noted that it was not in the blueprint he had drawn up but pointed out that the kind of catalytic converter he had used for the figure's head had metal edges with holes in them that looked like pierced earlobes: "The catalytic converter the way it was shaped, I looked, I said, 'Perfect, put an earring in there.'"

At some shops, such as Lincoln AutoRepair and Muffler in Santa Monica, California, individual mechanics may work on their own separate sculptures, meanwhile commenting on and making comparisons with others' creations. At different shops, the process of assembly is carried out as a group activity with coworkers all collaborating

on one sculpture and playing off each other's creativity. Father and son coworkers Yasir and Salvador Flores report that one of them will usually suggest an idea and the other will comment on or modify it. Duncan (Turp) Turrentine reported a similar way of working: "Some of the ideas, you know when you just draw a blank and you're looking at it, and you can't find anything, then all of a sudden one of us will come up: 'Well, how about this?' 'Yeah, that's what I was looking for, yeah, that's what I wanted.' Then bingo, it comes together. So, it helps to get two heads sometimes, 'cause you get stuck. You're going, 'I know what I want, but I don't know, I can't come up with it.' And someone else will come up with it. 'Yeah, this is it, okay. Yeah, tack it on.'"

As Gary Koppenhaver says of the process, "We get a kick out of it, we'd talk about it. Me and Turp are really good friends, so it's nice to make something together."

Muffler sculptures are a form of "accretive art" (Evans-Pritchard 1985: 11) in that they are open-ended creations that inspire ad hoc bricolage or pastiche. Exposed to weather, vandalism, and creative modification, they tend to change and evolve over time and are never really completed. Mechanics may dress the pieces in different articles of clothing or give them fresh coats of paint. Furthermore, individuals who were not present when the figures were first constructed may later contribute decorative elements. Features are altered as welds give and pieces that have fallen off need to be replaced, or as new parts are acquired that inspire further embellishment.

Sculptors describing the various pieces they have created provide insight into the process of construction. Faces light up and smiles broaden as they reminisce. Many mechanics refer to the manufacture of sculptures as "fun" or "getting wild," and narratives of creation echo the excitement or exuberance involved in construction. Gary Koppenhaver enthusiastically describes the process: "And then you don't want to quit when you start making it. You gotta turn customers away, 'Can you come back tomorrow [laughs]?' 'Cause you just want to keep on making it. 'Cause you got so much in your mind. I guess you could write it down and do it later. But it's inspiration as you're making it."

Workers clearly derive pleasure and enjoyment from making

sculptures and gain additional satisfaction with the improvement of techniques and skills. Frank Afra remarked, "The more I make, the more I get better." The process transforms the work experience by allowing the imaginative use of skills, equipment, and materials to take place in a creative and playful fashion. Such behavior leads to both individual and collective self-expression in the workplace; it is, as Yvonne Lockwood has noted, "the antithesis of mechanical, repetitive 'real' work" (1984: 205).

MORE THAN A MUFFLER: FORM AND MEANING

Sculptures assume an amazingly wide variety of forms, shapes, and sizes, ranging from tiny creatures only six or seven inches tall to giant beings that tower over their makers and reach heights of nine or ten feet. Numbered among the most common sculptural themes we have encountered are generic humanoids (men, women, and children), animals, robots, cowboys, sporting figures, cartoon characters, fantastic creatures, mythological or sacred beings, and national icons. As C. Kurt Dewhurst has noted, occupational arts tend to focus on workplace activities or the products of work on the one hand or depictions of "seemingly escapist or imaginary scenes" on the other (1984). Murals painted by Clarence Hewes while on the

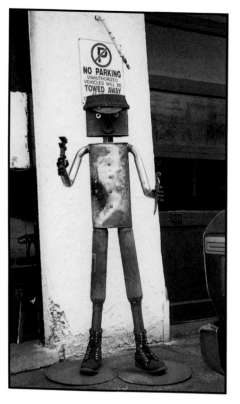

job at the Board of Water and Light Pumping Station in Lansing, Michigan, for example, range from portraits of his fellow workers to portrayals of Popeye and the Garden of Eden (Dewhurst 1984). Likewise, the scrimshaw carvings created by mariners depicted whale hunts and other work-related activities, as well as mermaids, beautiful women, and idealized images of home ports.

As with other occupational art forms, the creative representations crafted by exhaust mechanics reflect the realities of the workplace environment as well as more personal issues and escapist flights of fantasy. Like the mechanics who make them, some figures hold mufflers, other auto parts, or tools (fig. 28); some are outfitted in work gloves, welding goggles, and old shop uniforms (figs. 29, 30). In addition to reflecting the appearances of their makers, the sculptures also communicate emotions, ideals, and experiences that do not relate to occupational tasks. As Mike Hammond notes, "I do them certain ways because of certain ideas or how I feel, or things I've done in my life. I'm a musician as well, so I wanted to make the muffler band. . . . I used to race motorcycles, so I made a motorcycle, a Muffler-Davidson I call it" (fig. 31; see also fig. 12). Moving beyond the realms of personal or professional experience, muffler artists also enjoy fashioning more imaginative works. Kevin Doyle, for example, wants to construct a twenty- or thirty-foot-tall muffler dinosaur at his

Figure 28. Muffler mechanic. Mike Hammond. Melody Muffler & Lube Center, Walla Walla, Washington.

Figure 29. Muffler man holding signboard. Performance Auto Express, Walnut, California.

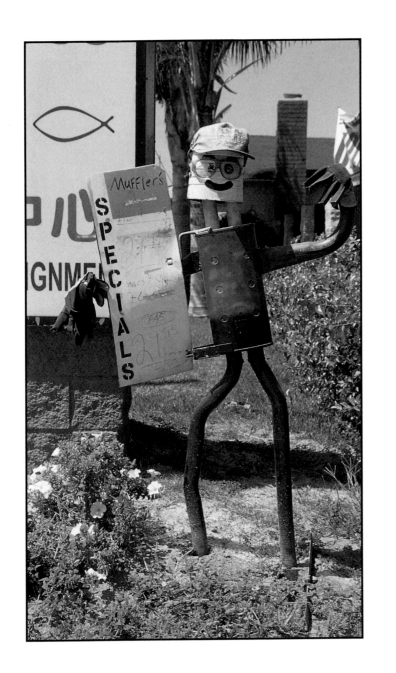

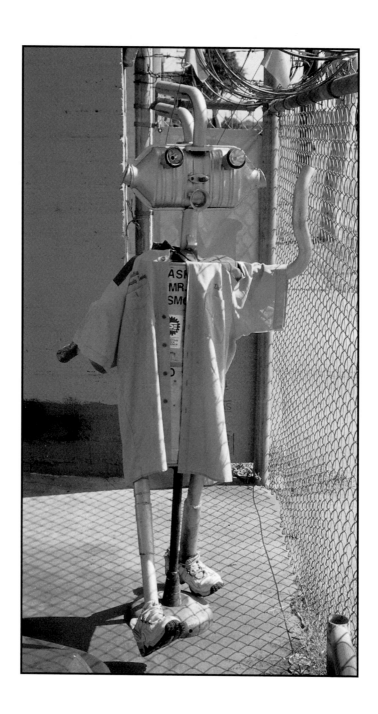

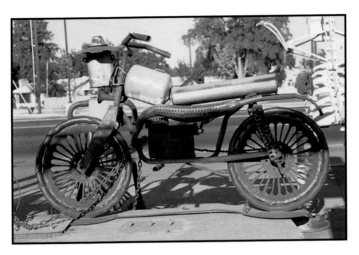

shop in Hollywood, Florida, because "a big green dinosaur on the side of the shop would stand out as something a little more unique."

METAL MEN, WOMEN, AND CHILDREN

Many, if not most, muffler sculptures appear to be three-dimensional renderings of the stylized "funny little man" graphic images featured on business signage or, more imaginatively, shop employees carrying out daily routines. Some sculptures greet passing traffic with outstretched arms and waving hands, while others point in the direction of the business (plate 7). Playfully dressed and described as "coworkers," the sculptures are incorporated into the workplace ethos. They are often given nicknames such as Pepe, Coco, Muffles, and Moe. In some cases, the names attached to the sculptures serve as sources of esoteric humor. As Kevin Doyle notes of one of his early works, "His name was Fred the Muffler Man. He was kind of a joke, because people would call up and say, 'I need to talk to the owner.' 'He's not here. He'll be here Monday, you gotta talk to Fred.' Fred was our guy and we're always closed

Figure 30. Sculpture dressed in old tennis shoes and work shirt. Ernie Diaz and Frank Esquivel. Smog Check, Gardena, California.

Figure 31. "Muffler-Davidson." Miniature motorcycle crafted from scrap metal and spare automotive parts. Mike Hammond. Melody Muffler & Lube Center, Walla Walla, Washington.

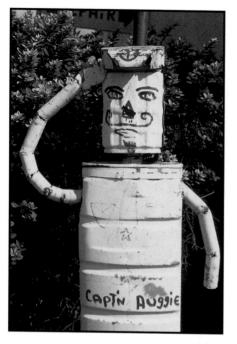

Monday. Occasionally they'd figure it out. Sometimes they wouldn't." At Lizarde Auto Service in Los Angeles, workers lining up for a group photo made sure to include their muffler man in the picture. Similarly, Augustin Olivo of Auggie's Muffler Shop in Downey, California, keeps a scrapbook with photographs of workers humorously posing with the shop's statue. In this context, Simon Bronner's commentary on the personalization of art is particularly appropriate: "Although objects stand apart, their relations with their human creators and owners are still recognizable. Human characteristics are attributed to object forms, so that chairs are described as having legs, lamps as having necks, clocks as having faces. Some people interact with objects as if they were people. They give them names, talk to them, and decorate or dress them. . . . So despite the 'otherness' of objects, humans nevertheless project their own ideals and emotions onto them and see them as reflections of themselves" (1986: 204). Composed of broken mufflers and bits of exhaust pipe, the sculptures nonetheless bear the likeness of humans and, if only in jest, are treated accordingly.

Sometimes muffler sculptures are conceived of as self-portraits or as caricatures of specific individuals with whom their makers are familiar. Francisco Solis, for instance, once dressed a small muffler man in his old shop uniform complete with a name tag on it that said "Francisco." Leo Sama of Eddy's Auto Repair in Santa Monica also created a muffler sculpture on which he painted his own name. When

Figure 32. "Captain Auggie." Augustin Olivo. Auggie's Muffler Shop, Downey, California.

Figure 33. "John." Gary Koppenhaver and Duncan Turrentine. G & R Mufflers, Lake Elsinore, California.

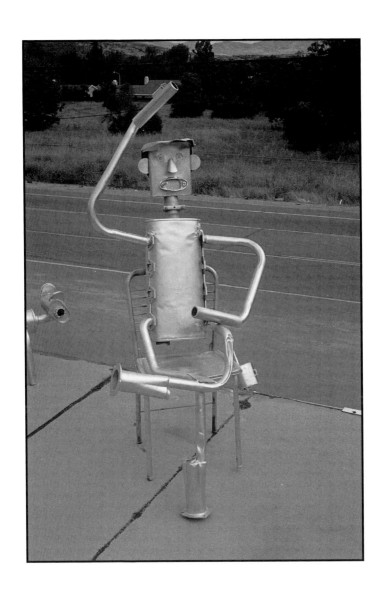

we asked about the sculpture's name tag, Leo chuckled and said, "That's me." Similarly, Augustin (Auggie) Olivo's muffler man has the words "Capt'n Auggie" stenciled on it by one of his workers (fig. 32). Another instance of the impulse to add personalized or biographical features to muffler sculptures was reported by Kay Turner, who found that workers at a repair shop in Texas had painted prison stripes on a figure as a send-up of a repairman who was on probation for a drunken driving offense (1996: 62). Additionally, employees at another shop showed us a small funny-looking sculptural figure wearing glasses made from thin welding rods. When we asked them if the work had a title, they laughed uproariously. After some prodding, they told us it was named after their boss, who was not privy to the joke. Repairmen occasionally modify existing sculptures so that they resemble certain persons or bring to mind characteristics associated with them. Cast-off or "borrowed" hats, shirts, or sunglasses are placed on figures that may thereafter be referred to by the name of the clothing's previous owner.

The horseplay, joking interactions, and "kidding themes" (Roy 1959–60) constructed around muffler sculptures create familiarity among fellow workers and relieve tension at the workplace. Comic self-portraits show that individuals can laugh at themselves, while caricatures of others function as a kind of mock aggression that both requires and reinforces intimacy and affection. However, in an instance such as one in which an employer was derisively compared to a bespectacled, frog-like sculpture that actually bore a slight resemblance to him and was named after him, the humor might be seen as deprecating. Based on a kind of in-group/out-group or employer/employee hierarchy, the behavior may serve to release pent-up hostilities by allowing workers to lampoon or belittle their boss (Apte 1985: 54ff.).

The intensely personal orders of meaning that can be inscribed on muffler sculptures are exemplified by two works displayed at G & R Mufflers in Lake Elsinore. Crafted by Gary Koppenhaver and Duncan Turrentine, the first figure depicts a man sitting in a chair (fig. 33). Stationed on the roof of the shop, the sculpture immediately captures the attention of onlookers. When we asked Gary to tell us about the piece, a slight smile appeared on his face and he

responded, "Oh, that's John."
As an explanation of how the
sculpture came to be so named,
Gary said it was patterned after
a former acquaintance, then re-
lated the following story: "[H]e
lived in the back house back
here and he used to come out
here, a retired old guy, smoked
a big fat cigar and just kinda
chewed the fat with everybody
else, with all my customers, a
public relations guy. He didn't
even work here. So when he
died I made that guy. . . .[W]e
made him, 'cause we kinda
missed him out here."

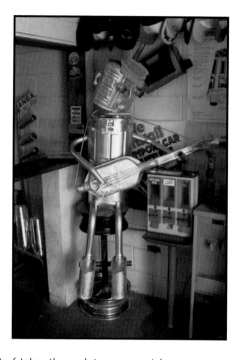

Created as an intimate portrait of John, the sculpture memorial-
izes their deceased friend. Using mufflers, exhaust pipes, and other
automotive parts, Gary and Duncan fashioned a monument that
serves as a permanent reminder of the most endearing aspects of
John's personality. Like the real John, the muffler figure smokes a
cigar and waves to passing traffic. Handcrafted objects of this type
provide "a way to materialize internal images, and through them
to recapture earlier experiences" (Kirshenblatt-Gimblett 1989b:
331). More specifically, as Michael Owen Jones writes, "[T]he loss
of a friend, a relative, or one's own health fosters introspection,
which may in turn promote the production of a song, story, or
other work. . . . [E]xpressive structures and objects that one creates
fill the void caused by loss"
(1989: 192). Summing up his
conception of the statue and
its meaning for him, Gary de-
clared, "Yeah, he's John. Yeah,
he's still up there."

Figure 34. "Paul, the Bass
Guitar Player." Gary
Koppenhaver. G & R Mufflers,
Lake Elsinore, California.

Also providing an excel-
lent example of how muffler
sculptures may be patterned

after specific individuals is a remarkable statue by Koppenhaver that depicts a musician playing a guitar (fig. 34). Seated on a cushioned chair made from used wheel rims, the muffler man's goggle eyes are focused downward towards the strings of his guitar. Placed jauntily on his head is a used baseball cap advertising a local business. Regarding the musical instrument the figure is holding, Gary states, "I knew this would be kind of like a Paul McCartney-style bass guitar. You remember Paul McCartney. Maybe that's what I made it after." Although the guitar is similar to the one used by the former Beatle, Gary did not intend the statue to be a representation of McCartney. Rather, the form of the work was influenced by Gary's own memorable experiences as both a musician and a music fan. The guitar player sculpture was partly patterned after a man who performs in the same musical group as Koppenhaver. With a wide grin, Gary says, "I kinda maybe modeled it after a buddy of mine named Paul. He's our bass guitarist. And that's why it's a bass. He's a tall guy. He puts on glasses now and then. Won't admit to it, so I put glasses on it. So I kinda made it after him a little bit. In fact, I have one of his business hats I put on him. . . . So when he came in one day, I said, 'There you go, that's you' [laughter]. He just kinda chuckled. And he doesn't have any hair on his head so we didn't put any hair on it [laughs]."

Upon taking a closer look at the guitar player, we noticed that it also appeared to be wearing elevator shoes. Assuring us that this was indeed the case, Gary laughingly reminisced, "In my childhood days in high school, I went to see Sly and the Family Stone. Back then, 1968, 1970s, platform shoes were around. And there was this guy in the crowd, he was a short guy. He was kneeling down but he had shoes this tall." Years later when Gary began work on the sculpture, he remembered the striking image of the diminutive man and his extraordinary footwear. He said, "And I remembered that guy and I said, 'Hey, that would be kinda cool out of mufflers.'"

Although the stylistic details of the two sculptures at G & R Muffler can be readily appreciated and enjoyed by anyone who passes by the shop, the works additionally act as repositories for Gary's own life experiences. As Christopher Musello has noted, "The things with which we surround ourselves, may, and commonly do, become inscribed with multiple valences of significance,

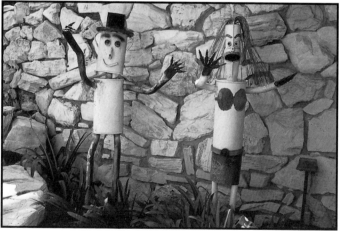

Figure 35. "Bad Hair Day."
Gary Koppenhaver and Duncan
Turrentine. G & R Mufflers,
Lake Elsinore, California.

Figure 36. Muffler couple
installed as yard art, Beverly
Hills, California. Works by
Frank Afra. Affordable Muffler
and Auto Repair, Los Angeles,
California.

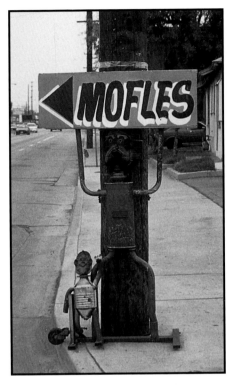

with each level of meaning modifying the other" (1992: 37). The process of artistic creation enabled Koppenhaver to express, among other things, personal interests, nostalgic memories, and joking relationships; the sculptures hold meanings that often go unarticulated or are shared only among members of his immediate group of coworkers and friends.

Although not nearly as prevalent as muffler men, sculptures depicting female characters can be found at a number of repair shops (fig. 35). Most of the muffler women we have encountered are located at businesses that also feature one or more male figures. According to many artists, the ongoing creation and display of detailed masculine sculptures eventually leads to the production of statues of women. The lack of female companionship at many of the garages that we have visited may also have something to do with this recurrent theme. We have routinely noted pinup girl calendars at muffler shops, and some of the artists' comments affirm that the works represent idealized images of women. Concerning the female figures he has crafted, Frank Afra states, "I made very exotic women and very sensual women. I put boobs on them, bras, bikinis. I made beautiful faces on them, you know. . . . I made mostly modern women; modern, sophisticated women." Frank repeatedly emphasized to us that his women are "pretty," or have "beautiful blonde wavy hair" (fig. 36).

Because female muffler sculptures are almost by necessity

Figure 37. Adult with child. Carlos Gonzáles. A & R Muffler, Huntington Park, California.

rendered anatomically correct, such figures often pose artistic and representational dilemmas for repairmen. Passersby may object to the display of breasts or may interpret the sculptures as sexist. Asked if he had ever made a female sculpture, Kevin Doyle replied, "Not yet. Not yet. They wouldn't be the most attractive." He was once invited to create a muffler display for a bridal show, but he says, "I wracked my brains and couldn't come up with an angle for that one. I really couldn't. They were gonna give me free display space in their bridal show at a mall, but I just didn't know what to make."

Having made several muffler men, Gary Koppenhaver and Duncan Turrentine decided that they wanted to design a female sculpture. They were concerned, however, about the possibility that the creation might offend the general public.

> Duncan: We gotta think up a deal for a gal.
> Gary: Yeah, we want to build a muffler girl.
> Duncan: A singer or something.
> Gary: We don't want it to be too explosive a type of thing.
> Duncan: Just enough to make it so you know it's a female out there.
> Gary: Maybe a female type of thing . . . we gotta think of how to make a girl. Probably has something to do with the hair. That's gonna be a kinda tough one to figure that one.
> Duncan: Yeah, we'll get it . . . one of these days.

When we visited Gary and Duncan several months after this conversation, they had just finished constructing their first of several muffler women (plate 8). Although the two had initially contemplated making her a musician, the final result of their experiment was a sculpture they referred to somewhat sheepishly as a "Harley-Davidson biker babe." According to Gary, a Harley-Davidson enthusiast himself, the work depicts a weekend persona adopted by some female motorcycle enthusiasts who might be lawyers, office workers, or housewives.

Mechanics occasionally endeavor to provide mates and even offspring for their muffler men (fig. 37). Mike Hammond's first sculpture at Melody Muffler was a piece entitled "Muffler Man." After a while, Mike and his coworkers decided that he was "getting lonely" out in front of the shop, so they built him a mate named

"Muffy." A muffler child entitled "Son of Muffler Man" and a dog called "Spot Weld" soon rounded out the family (plate 9). Groupings of muffler sculptures displayed at other shops have also been referred to as "muffler families." For example, the collection of sculptures at G & R Mufflers has, on several occasions, been referred to by the media as the "Lake Elsinore Muffler Family." This happened even before the mechanics had fashioned their first female figure.

ANIMALS

Sculptural renditions of animals, both domestic and wild, are especially popular among repairmen. Statues representing household pets, livestock, and a host of exotic metallic beasts inhabit the grounds of repair shops throughout the United States (figs. 38–43; plates 10, 11). With their oddly curved pipes that often seem to replicate tails, used mufflers sometimes evoke animal forms. Reminiscing about the source of inspiration for one muffler creature, Frank Afra said, "I remember this guy came in, his car engine backfired, it blew the muffler. . . . When it exploded it made a shape of an animal, the belly and everything. . . . When it cracked, it made ribs. . . . When I looked, I said, 'Ooh, this will make a good animal.'" One of Afra's workers picked up the muffler and started to take it outside to the junk pile, and Frank yelled to him, "Bring it back!" As soon as he got a chance, Frank welded some exhaust pipes from a Volkswagen onto the muffler to serve as legs and then used a metal cone for a head. Afterwards, he painted the whole thing black and put it outside his shop. Commenting on a type of blown-out muffler that motivated him to make a series of cats, Afra stated, "They are the worst design for an exhaust system on a car. I hate them. But for statues, they're perfect" (see fig. 26). Mike Hammond asserted, "There's a particular catalytic convertor that we always wait for, that makes a good turtle."

Some repairmen have created veritable muffler menageries. In Los Angeles, Joe Loria recalls the existence in the 1970s of an assemblage that he referred to as a "petting zoo." Before Muffler City in Belmont, California, closed down in the late 1990s, the shop

Figure 38. Zebra. Frank Afra. Affordable Muffler and Auto Repair, Los Angeles, California.

Figure 39. "Dumbo." Mike Hammond. Melody Muffler & Lube Center, Walla Walla, Washington.

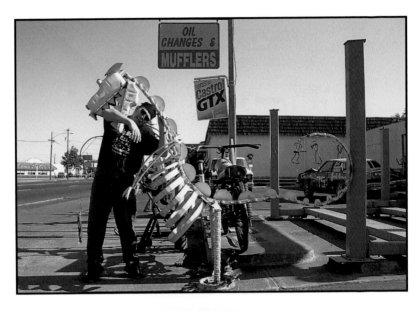

Figure 40. "Metalsaurus."
Mike Hammond. Melody
Muffler & Lube Center, Walla
Walla, Washington.

Figure 41. "Albino Rhino."
Kevin Doyle. Mad Hatter
Muffler, Hollywood, Florida.

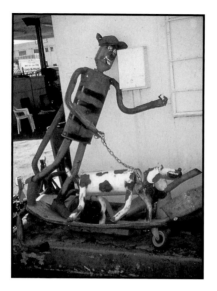

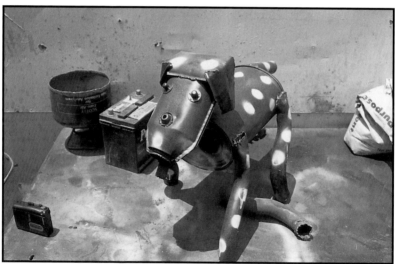

Figure 42. Man with dog. George Luna and Robert Luna. The Bomb Shop, Los Angeles, California.

Figure 43. Dog. Salvador Flores and Yasir Flores. La Tortuga Auto Repair, Los Angeles, California.

featured a deer, an eagle, and numerous other critters that were positioned so that they could be seen by passengers on commuter trains (muffler man sightings). At Melody Muffler & Lube Center, Mike Hammond has displayed more than a dozen animals, including a ram, a turkey, dogs, goats, elephants (fig. 39), snakes, insects (plate 10), and a dinosaur (fig. 40). In Florida, Kevin Doyle maintains what he calls "Mad Hatter zoos" at each of the two repair businesses he owns. Among the animals in these collections are an alligator, dogs, a duck (plate 11), a giraffe, a horse, rabbits, reindeer, snakes, a caterpillar, and an albino rhinoceros (fig. 41).

Dogs, especially spotted ones, are the most common animal figures (figs. 42, 43; see also fig. 23). Easy to make and handle, these "muffler mutts" are a great source of pleasure and amusement for artists and audience alike. Sometimes the canine sculptures are placed next to muffler men as if to prove the adage that dogs are man's best friend (fig. 42). Although he makes other types of figures, Kevin Doyle prefers to fabricate dogs for a number of reasons. He says, "I can have more fun with them because they're small, they're easy to transport, they don't take up much space when I build them."

IMAGES FROM FOLKLORE AND POPULAR CULTURE

Because muffler figures are likely to attract more attention when they are rendered in forms that are identifiable and have broad appeal, mechanics frequently pattern them after recognizable icons drawn from folklore and popular culture. According to Peter Narváez and Martin Laba, these two "organizational modes of activity in a social order" are particularly rich sources of creative inspiration, as they provide artists with "repeatable expressive forms for individual and group experiences in everyday life. In other words, they offer a

Figure 44. Robot. Victor Lopez. Lincoln AutoRepair and Muffler, Santa Monica, California.

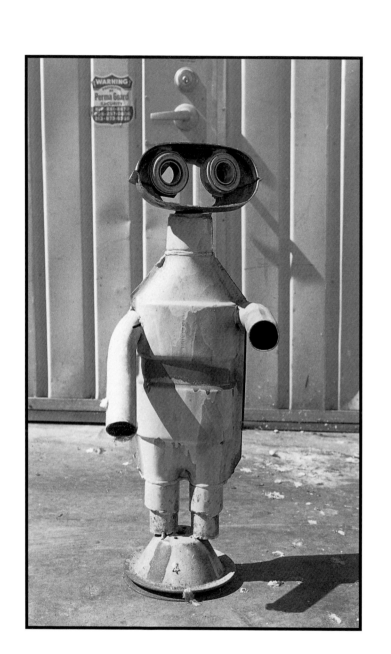

means of rendering experience intelligible and graspable through recognizable forms that are both pleasing aesthetically and relevant in a social interactional sense" (1988: 2).

Reflecting their own cultural milieus, business advertisements are literally signs of the times. Whereas early modern English signage referenced topical historic personas, characters from popular ballads or chapbooks, and legendary figures such as Admiral Benbow, Guy of Warwick, or the "Wild Man" (Larwood and Hotten 1866), the sculptural motifs commonly employed by muffler sculptors include cowboys, robots, and cartoon characters.

Whether described as "core," "dominant," or "key" symbols, these expressive forms represent fundamental cultural ideas or concepts shared by muffler repairmen and many of those who view the sculptures they craft (Ortner 1973). A muffler turkey fashioned at Thanksgiving time, for instance, may reference the narrative of the Plymouth pilgrims and evoke patriotic feelings concerning freedom, democracy, and perseverance in the face of adversity, while a sculpture of a baseball player may embody ideals of competitiveness or foster shared fan identity. In each case, such figures speak in a recognizable symbolic idiom or language.

Robots and Rocket Men

Reflecting the long-standing fascination with humanized automatons that permeates modern society, some muffler sculptures have decidedly android-like features and are specifically referred to by their makers as robots (fig. 44). Part of the allure of automatons, whether actual technical innovations or their sci-fi counterparts, is derived from the fact that they can accomplish tasks we do not like to do or cannot do given our physical limitations. While offering the dream of freedom from mechanical drudgery, popular culture representations of robots also highlight the humanness of those forced to carry out repetitive and sometimes dangerous labor. With the advent of the assembly line and the increased mechanization of modern society, "human beings have been required as never before to function as extensions of machines" and robots have thus been interpreted as "analogs of our dehumanized selves" (Aldiss 1982:

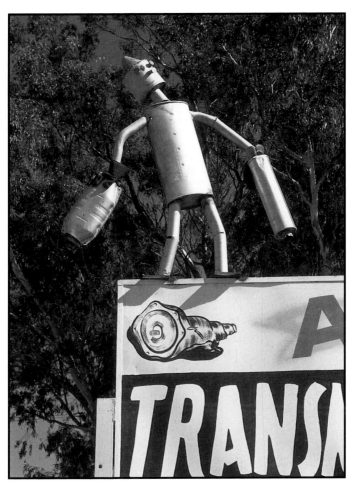

Figure 45. A & S Muffler, Perris, California.

7–8) or as ways of "looking at Man in the context of his machines (Stableford 1987: 110).

Drawing on mass media images such as the "droids" in *Star Wars*, the Tin Man in *The Wizard of Oz*, and other robotic figures celebrated in works of fantasy and science fiction, muffler sculptors craft futuristic beings out of the detritus of contemporary automotive technology (fig. 45). After fashioning the giant muffler automaton stationed at his shop in Carson, California (see fig. 3), Joe Loria and his employees created a sculpture for his shop

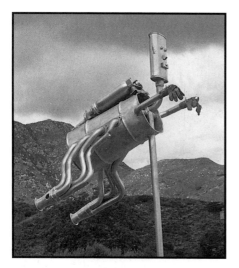

in Riverside that was modeled after the robot character Johnny-Five in the feature film *Short Circuit*. Several mechanics have pointed out that the precision-machined design of automotive parts is tailor-made for use in crafting fantastic mechanical figures. A large and unusual muffler extracted from a motor home, for instance, inspired Gary Koppenhaver and Duncan Turrentine to craft an eight-legged rocket man (fig. 46). Describing the process of brainstorming that led to the creation of the sculpture, Duncan stated, "That rocket thing on the guy's back we had in the back, and we talked about it—'that looks like something you'd put on your back and fly around with.' And that's all that took."

Cowboys

Polyvalent symbols of an idealized American past, cowboys are also a recurrent theme, and we have seen them at half a dozen different shops (fig. 47; plate 12). Popularized through fiction, film, television, ballads, rodeos, and wild west shows, cowboys and *vaqueros* have ridden, roped, shot, and sung their way into the imaginations of children and adults the world over. Romanticized folk heroes of mythic proportion, they symbolize, among other things, rugged freedom, self-reliance, sex appeal, and adventure. As fantasy ideals, they help us to imaginatively escape our humdrum existence, if only for a moment (Taylor and Maar 1983).

Figure 46. Rocket man. Gary Koppenhaver. G & R Mufflers, Lake Elsinore, California.

Cowboys are one of Frank Afra's favorite sculptural subjects, and he has constructed at

least seven over the course of the last decade (fig. 48). When asked why he made the sculptures, Frank first pointed out that customers and passersby love muffler cowboys. On a more personal level, he also noted, "I lived in Texas—Dallas, Texas. I worked for a corporation. On Fridays . . . the employees had to dress like cowboys. So I invested in lots of western wear for my job. Then I was inspired. I lived with cowboys; it was a fascinating life." In addition to being "inspired" by his occupational costuming in Texas, Frank indicated that he used to draw pictures of cowboys when he was a child. He says, "I was very fascinated with cowboys." Reflecting the well-defined dichotomy between good and evil characters that pervades Hollywood westerns, Frank's statues depict lawmen complete with sheriff's badges and villains clad in black and wearing kerchiefs over their faces.

Like Frank Afra, Gary Koppenhaver also has a fondness for the popular images associated with cowboys, a fascination that finds expression in one of the sculptures displayed at G & R Mufflers (fig. 49). Representing a

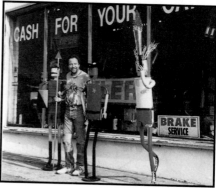

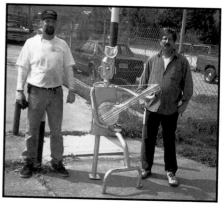

Figure 47. Head shot of muffler cowboy. Salvador Flores and Yasir Flores. La Tortuga Auto Repair, Los Angeles, California.

Figure 48. Fred Afra (Frank's brother) posing with sculptures. Affordable Muffler and Auto Repair, Los Angeles, California.

Figure 49. Gary Koppenhaver and Duncan Turrentine with Muffler Cowboy. G & R Mufflers, Lake Elsinore, California.

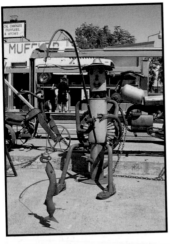

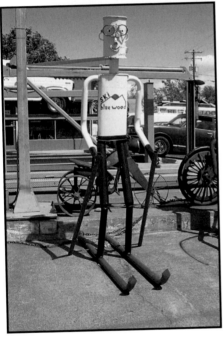

banjo-playing wrangler, complete with a "six-gallon" hat, the work was actually created by Duncan Turrentine. Prompted by Gary's interest in horses and the cowboy lifestyle, Duncan manufactured the statue during a period when Gary was away on holiday. Before Gary's vacation, the two men had discussed how one of the used mufflers in their junk pile would make a good banjo, but that was as far as they had gotten with the idea. So, during Gary's absence from the shop, Duncan assembled the cowboy figure and presented it to Gary as a surprise upon his return. The endeavor enabled Duncan to express his own artistic vision while at the same time providing his friend with a present he was sure to enjoy.

Sporting and Leisure Activities

Figures depicting recreational or professional athletic activities such as baseball, boxing, running, skateboarding, and pitching horseshoes also frequently grace the fronts of muffler shops. In general, the figures represent either leisure activities that their makers engage in during

Figure 50. Fisherman reeling in a "steelhead trout." Mike Hammond. Melody Muffler & Lube Center, Walla Walla, Washington.

Figure 51. Skier. Mike Hammond. Melody Muffler & Lube Center, Walla Walla, Washington.

off-hours (e.g., riding motorcy-
cles, skiing, golfing) or sporting
events that the sculptors enjoy
as fans but not as active partici-
pants (figs. 50, 51). Some stat-
ues were manufactured because
the sport they represent was a
frequent topic of conversation
in the shop. Frank Afra reported
that he first made a sculpture of
a prizefighter because "my me-
chanics were always talking
about boxers . . . so I designed
one" (fig. 52). The piece caused
such a sensation among Frank's
coworkers and customers that
he felt compelled to make

more. He also once created a baseball player in order to mark the
opening of the professional baseball season (see plate 1) and fash-
ioned a sculpture of an Olympic torch runner after observing the
ceremonial torch procession that preceded the 1996 Olympic
Games (see figs. 25, 48). Motivated by the same experience, Jim
Wilson of Wolfman's Muffler Center in Newnan, Georgia, also built
a muffler torch bearer and placed it near the street in front of his
shop when the torch-bearing runners passed by on their way to At-
lanta.

Occasionally, figures with sporting themes reflect unique occur-
rences in the sports world or emergent team traditions that have
captivated fans. Several years ago, for example, Kevin Doyle cre-
ated a series of sculptures
depicting large rats wearing
Florida Panther jerseys and
holding hockey sticks (fig.
53). Concerning the inspira-
tion for these odd pieces,
Doyle states, "That goes
back to a couple of years ago
when the Florida Panthers

**Figure 52. Passerby playfully
sparring with muffler boxer.
Affordable Muffler and Auto
Repair, Los Angeles,
California.**

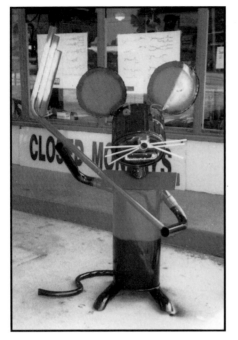

hockey team got to the Stanley Cup playoffs, and several customers had come in and they had seen the rabbit and the other stuff and they were joking around . . . saying, 'Why don't you make a big rat with a hockey stick.' I don't know if you remember the rats being thrown on the ice. That was hot down here. There were rubber rats going out there like crazy. Because the one player that pulled a hat trick that night, while the reporter was interviewing him before the game, a rat ran across the locker room floor and he smacked it with his hockey stick, and then he went out that night and scored, I believe it was, three goals. So it was good luck to smack the rat around, and it was just a chain reaction. So I made that Panther rat with a hockey stick." As an artist, Kevin was especially pleased by people's positive reactions to the Florida Panther rats. He says, "I've sold two of those to Panther fanatics. They have to have it."

Sometimes shop workers decorate preexisting sculptures with hats, shirts, or stickers bearing the logos of their favorite teams. Becky Glenn of Glenn's Muffler Shop in Seneca, South Carolina, once dressed the muffler figures at her family business in the local high school's football and cheerleading uniforms (plate 13). One year, Tom Gannon of Phoenix, Arizona, placed a Phoenix Suns jersey on one of his creations in order to help cheer on the local professional basketball team (Gilstrap 1997).

Figure 53. "Hockey Rat." Kevin Doyle. Mad Hatter Muffler, Hollywood, Florida.

Sculptures of athletes may also be created simply because a muffler repairman owns or

acquires used parts or other materials that suggest a particular sporting image. Frank Afra was once inspired to fashion a muffler golfer after he came across an inexpensive golf club at a local junkyard. Likewise, Gary Koppenhaver crafted a race-car driver muffler sculpture because he had the shell of a go-cart he had started building for use in racing but never actually finished (fig. 54). He says, "By the time I would have got done making [it], we would have had about eight hundred bucks in it. So I had this frame, so I said, 'You know, I ought to put a muffler man in that guy.'"

Cartoon Characters and Fantastic Creatures

The construction of muffler figures is often likened to the drawing of cartoons. Mike Hammond even created a comic book and handed out copies of it to children who visited his shop (fig. 55). The work tells the story of how his sculpture, Muffler Man, and his family traveled to earth from the planet Muff in order to help clean up the environment. In the illustrated narrative,

Figure 54. Race car driver. Gary Koppenhaver and Duncan Turrentine. G & R Mufflers, Lake Elsinore, California.

members of the muffler family are described as "super heroes" who "inhale pollution and noise and exhale silence and clean air." More commonly, however, muffler sculptures are based on preexisting cartoon characters. In the Los Angeles area, we have found three different Pink Panthers, one of which has acquired such a notable status within the muffler repair community that workers at several different sites told us we had to go see it (plate 14). Frank Afra has created both a large muffler Gumby (see plate 1) and a metallic version of Bart Simpson. Asked why he made the Simpson character, Frank responded, "I did the Simpson one because [of] my kids. I used to sit—see, I like satire. . . . My kids, they liked the show; I liked the show. . . . I had the material, I didn't have a big muffler, I had a small one, so I wanted to do a small one. Pipes that I got from a small car like a Toyota Tercel, they were small, see what I mean. The combination of raw material, the combination of love, of fondness for a TV show, my kids influenced it, too."

The meanings and motivations that Frank attaches to the muffler figure demonstrate a "multiplicity of identities" (Dewhurst 1984:193). The various social roles Frank plays and the domains through which he passes in his day-to-day life—father, fan of the television program *The Simpsons*, car repair shop owner, recycler, and artist—are all brought to bear in his creation and display of the figure.

Figure 55. Page from muffler man comic book. Mike Hammond. Melody Muffler & Lube Center, Walla Walla, Washington.

Like cartoon characters, fantastic or extraordinary creatures are also prevalent. The availability of uniquely shaped metal parts enables muffler artists to let their imaginations run wild.

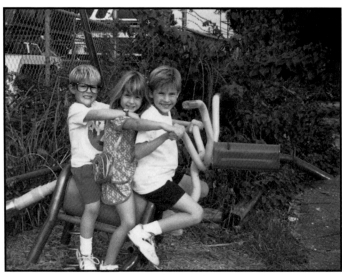

As a result, they often create works representing beings of long-standing popularity as well as previously unimagined beasts. Muffler City in Belmont, California, displayed a large muffler dragon for a number of years, and San Bernardo Mufflers in East Los Angeles features a Minotaur-like statue dubbed "El Toro." Similarly, Kevin Doyle was inspired by his children to craft a sculpture bearing the Dr. Seuss-like name "Whatsit" (fig. 56). Welded to a large coiled spring, the piece rocks back and forth and can actually be ridden by one or more children. More so than any other repairmen we have encountered, Mike Hammond and his coworkers specialize in the manufacture of strange creatures. Among their creations are an iguana wearing a top hat (actually a reference to Hammond's rock 'n' roll band Iguana Hat), a pig with wings, a gargoyle, a miniature Loch Ness monster, and numerous other imaginative beasts (fig. 57; plate 15; see also fig. 64; plate 4). Influenced by popular literature, tabloid journals, and abduction tales, Miguel Gutierrez crafted an image of an alien holding a baby (see fig. 14). The child *muñeco*, according to Miguel, had been born on earth and was being taken back to outer space.

Figure 56. "Whatsit." Kevin Doyle. Mad Hatter Muffler, Hollywood, Florida.

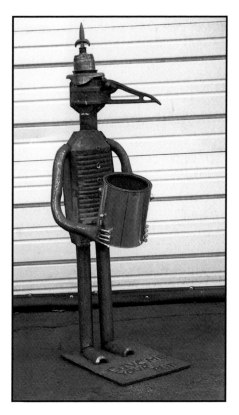

Religious, Holiday, and National Icons

Occasionally, sculptures are patterned after mythological and national icons that have significant religious, social, or political meanings for their makers. Inspired by the hagiography of the Catholic Church, for example, Teodore Quintero of Phoenix, Arizona, fashioned a statue named after San Jeronimo (Gilstrap 1997). Since this saint serves as the patron of metalworkers, a more appropriate theme for a muffler sculpture is hard to imagine. Figures representing devils and other horned creatures have been crafted by Latino automotive repairmen, an artistic preference that may be based on the prominence of such beings in Latin American oral traditions and sacred arts (Kitchener 1994) (plate 16).

Holidays and civic celebrations also inform the production and use of muffler sculptures. Commenting on the proliferation of publicly displayed holiday icons, Wilbur Zelinski asserts that such signage "reaches heights in the United States far beyond anything that foreign competitors can scale" (1994: 274). While he may be overstating the case, the American propensity for employing seasonal decoration certainly affects muffler art. These creations indicate holiday spirit and a partaking of the community identity through the custom of decorating homes and businesses. Muffler repairmen routinely festoon their sculptures with decorations—lights, ribbons, balloons—that

Figure 57. "Horus." Carl Van Scotter. Melody Muffler & Lube Center, Walla Walla, Washington.

are appropriate for various seasonal festivities. Special sculptures may also be created in keeping with holiday themes (fig. 58). Mike Hammond, for example, has fashioned several Thanksgiving turkeys (plate 17) and even a Halloween pumpkin using automotive detritus.

This impulse to create holiday assemblages is particularly well exemplified by the ever-changing muffler displays that are set up by Becky Glenn of Glenn's Muffler Shop in Seneca,

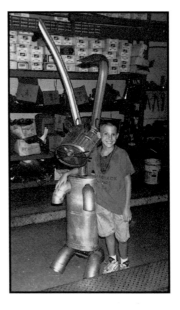

South Carolina. Becky is a notable exception within an artistic tradition that is predominantly a male endeavor. Her son Tommy and husband Tom first began making and displaying muffler sculptures in the early 1990s, initially just painting the figures and placing them outside the shop. But when they added a female to the ensemble, Becky began to dress the figures in clothing she purchased at the Salvation Army thrift store or that she received as donations. Over the last several years, Becky and her family have produced muffler dioramas depicting Halloween, Thanksgiving, Christmas and other celebrations (Horton 1998) (figs. 59, 60).

Christmas is apparently the favorite holiday among repairmen for seasonal embellishment of muffler figures. Throughout the country, mechanics decorate their works with Christmas lights and other cheerful accessories. A number have fashioned sculptures in the likeness of Santa Claus and his reindeer, most frequently Rudolph. In 1997, as Christmas approached, Frank Afra sculpted a Santa Claus figure. Describing a reindeer statue permanently displayed in front of his shop, Mike Hammond stated, "We

Figure 58. Easter bunny. Kevin Doyle. Mad Hatter Muffler, Hollywood, Florida.

Sabrina Dawson & Tommy Glenn Aug. 7, 1999

painted his nose red—Rudolph the muffler reindeer" (fig. 61). Kevin Doyle created an entire Christmas collection, including a Santa Claus, a sleigh, and a number of reindeer, one of which was known as "Rudolph the two-nosed reindeer" (plate 18). One year, Doyle installed his sculptures at a local holiday spot named Santa's Magical Village. He describes the diorama: "It was entitled 'The Muffler Dogs' Christmas.' So there were about twelve dogs of different shapes and sizes set up on display and the Santa Claus was being pulled

Figure 59. Thanksgiving muffler display. Glenn's Muffler Shop, Seneca, South Carolina.

Figure 60. Wedding announcement. Glenn's Muffler Shop, Seneca, South Carolina.

by the reindeer. And for his big bag, I took a dining room table cover, a big green cover, and folded it all up and tied it in a knot. Tied it with a rope, and I went to the party supply store and I got a bunch of plastic bones and I put bows on them and stuck them in the back of the sleigh. And then a friend of mine loaned me the CD of the barking dogs. The Jingle Bells and all the others, and we had that on a CD player constantly playing in the background. You had to get up on the display to appreciate it. But Santa was bringing all the big rubber bones to the guy." Doyle subsequently sold all of the muffler reindeer, but he has kept the Santa Claus and the sleigh. As is often the case with holiday decorations, they are kept in a storage area for most of the year and brought out as Christmas approaches.

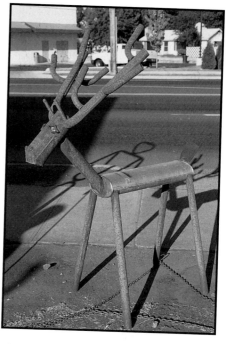

The desire to demonstrate significant ethnic or national affiliations may also inform the manufacture, decoration, and display of muffler sculptures. A number of Latino repairmen in Los Angeles have, for example, painted stylized versions of the Mexican flag on their *muñecos* or stenciled nationalistic slogans such as "Viva Mexico" on them. The names of different Mexican states such as Sonora or Jalisco have also been spelled out on sculptures. One year, in conjunction with a festival celebrating the feast day of La Virgen de Guadalupe, repairmen at AAA Mufflers and Radiators in Los Angeles decorated a muffler figure with a Mexican flag and with balloons in Mexico's national colors—red,

Figure 61. Reindeer. Mike Hammond. Melody Muffler & Lube Center, Walla Walla, Washington.

white, and green (plate 19). In a similar fashion, on St. Patrick's Day in 1999, Kevin Doyle painted several of his dog sculptures green, white, and orange in tribute to the banner of the Republic of Ireland and dubbed the creatures "Irish Muffler Hounds" (plate 20).

Also in recognition of national identity, Mike Hammond routinely affixes key icons of the United States of America to his sculptures at the appropriate moments. He says, "If it's Veterans Day we fly some flags and put some patriotic things on there." Each year, in celebration of the Fourth of July, Becky Glenn transforms a muffler sculpture into a metallic version of Uncle Sam by placing a star-spangled party hat on his head and attaching a long white costume beard to his face. In 1999, she posed the Uncle Sam figure together with four other sculptures representing the army, navy, air force, and marines; all were appropriately attired in surplus military uniforms (plate 21).

As Gerald Pocius points out, art "through form and through association of that form to particular aspects of daily life succeeds by eliciting some type of emotional response in others" (1995: 420). Thematic sculptures enable automotive repairmen (and their families, friends, and neighbors) to communicate their interests, fantasies, concepts of self, and notions of collective identity with others. After all, as Duncan Turrentine explains it, a primary objective of creating muffler art is to make "stuff that people can relate to and enjoy."

REALISM, DETAIL, AND HUMOR

Muffler sculptures have broad appeal; they are amusing to passersby who can see that these works are manifestations of creative ingenuity and artistic elaboration. As Gary Koppenhaver says of the art form, "I think all people get a kick out of it, kinda the kid thing in their mind. . . . People always look for something to be happy about. There's so many weird things in the world anymore. It's kinda neat to look at something that's comical and get a chuckle, 'cause laughing is good anyway. [It's] something they can relate to in their childhood, just like a toy." The amusement experienced by pedestrians and customers is, in turn, a source of enjoyment for the

sculptors. As Kevin Doyle has noted, "If you're sitting out here watching the people, you'll crack up."

Much of the pleasure derived from manufacturing and from viewing muffler sculptures comes from the achievement of realism and the creative, detailed elaboration of visual ideas. Muffler figures are grounded in, or conjoined to, reality in a variety of ways. As with snowmen or harvest figures (Neal 1969), the artworks are

often attired in human clothing: gloves, shoes, ties, and hats. Many of Frank Afra's sculptures incorporate human accessories as a finishing touch. His first prizefighter, for example, wore real boxing gloves. Mike Hammond often places real shoes on the feet of his sculptures, and Becky Glenn puts wigs on her muffler people. By dressing the muffler sculptures in clothes of the sort that we ourselves might don in everyday life, garage employees create a kind of comic mirroring of reality: the muffler figures are like us, and we are like them. The juxtaposition of the human and the mechanical in such whimsical and nonroutine contexts creates a humorous analogy between the handmade objects and their makers.

Many sculptures are notable for the attention their makers paid to the minutiae of realistic detail: boxers with blood dripping down their faces, tie-strings on their boxing trunks, gold belts, belly buttons, and nipples; cowboys with guns, badges, cigarettes, spurs, and horses; women with breasts, earrings, and high-heeled shoes. Features such as eyes, mouths, and ears made from bolts, wires,

Figure 62. Detail of muffler man's hand. Salvador Flores and Yasir Flores. La Tortuga Auto Repair, Los Angeles, California.

and other bits of scrap impart wonder to the observer (see figs. 47, 64; plate 6). Frank Afra has created numerous figures with cigarettes or pipes in their mouths. He says, "It will give them character. General MacArthur smoked, remember the corncob pipe? It gave him

character." Seeking realism, Yasir and Salvador Flores spent four hours constructing the hands on the muffler sculpture displayed at their shop; the joints of each finger were articulated with separate pieces of piping. Carefully shaped metal fingernails were then added for even greater detail (fig. 62). Characterizing his own efforts to achieve verisimilitude with the sculptures on which he has worked, Duncan Turrentine declared, "It seems like a challenge now. 'Cause you look at this guy, you look at the other guy, you look at these two and they're livelier. You try to make them more real."

To impart a sense of realism, sculptors tend to favor action poses that show figures frozen in midmotion. Frank Afra's Olympic torch runner, for example, has one leg raised off the ground and his hair is blown back, so that he appears to have been caught in the act of running with the sacred flame (see figs. 25, 48). Gary Koppenhaver and Duncan Turrentine spend a great deal of time shaping the limbs of their sculptures with a pipe-bending machine in order to make the works seem more lifelike. As Duncan notes, "He bends [the limbs]. I pose, and he bends a pattern: 'How's this, how's that?' I'm the model, I guess. . . . It's easier when some guy is posing for you." In some cases mechanics position sculptures together to form ensembles so that the figures appear to be interacting with one another. Frank Afra, for instance, situated two boxer sculptures so that they looked as if they were engaged in a fight. In a similar playful fashion, Kevin Doyle once placed a large dog bone in the hand of one of his muffler men and then surrounded him with five muffler dogs who seemed to be eagerly awaiting a treat.

Workers at a few shops have even kinetically animated their muffler figures. A pair of sculptures we encountered had rotating signs affixed to them that would spin whenever the wind blew in the right direction. A statue displayed at Auto Tech 1 in Wilmington, California, had a battery-powered flagpole attached to the top of its hat. When a small electric motor was switched on, the flag shaft circled around and the banner attached to its tip fluttered and flapped. Kevin Doyle's "Whatsit" and several other spring-loaded "playground" sculptures he created also provide elements of dynamic action to an otherwise static art form (see fig. 56).

Attempts to bring the mannequins to life are not limited to the

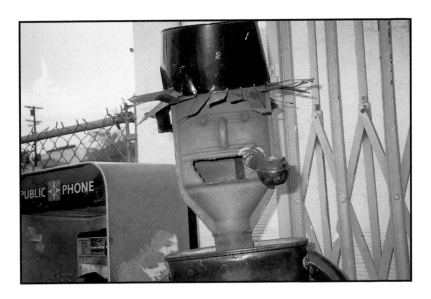

use of movable parts. Frank Afra animated one of his sculptures by making it appear to be smoking a real tobacco pipe. He says, "One time I took my mop, my old mop, we have lots of chemicals on the floor . . . so this thing, you cut it, you put it in the [muffler man's] pipe . . . you light it, it keeps burning, because of the chemicals in there. . . . So I put one outside [laughing]. It was smoking all day, and people were so fascinated [long laughter]" (fig. 63). Joe Loria gleefully told us that in the past he has attached a remote-controlled tape recorder to his robot so that he could make the sculpture "talk" to children as they passed by the shop. When they approached, he would activate the recorder and the robot would address them, saying such things as "Hello, kids" and "Tell your parents to come to Carson Muffler for their car work." This interaction, says Joe, "would just blow their minds."

The sculptures evoke and inspire mirth not because they exactly replicate humans or animals, but because mechanics go to great lengths to create realistic detail using, of all things, damaged car parts. Ludicrous in their conflation of categories, the metallic figures exemplify "appropriately incongruous"— thus, humorous—creations

Figure 63. Detail of muffler man's face with pipe. Frank Afra. Affordable Muffler and Auto Repair, Los Angeles, California.

(Oring 1992). As James Beattie asserted, "Laughter arises from the view of two or more inconsistent, unsuitable or incongruous parts or circumstances, considered as united in one complex object or assemblage" (cited in Oring 1992: 2). Depictions of people made from automotive detritus are absurdly artificial and "incongruous" in and of themselves, yet anatomies consisting of eyes, fingers, mustaches, and nipples carefully and "appropriately" crafted from bolts, spark plugs, wire, and other odds and ends are powerfully evocative. Even if the sculptures don't amuse viewers outright, as "ironic forms of refabrication" (Cerny and Seriff 1996: 25) erected through the recycled and creative reinterpretation of materials at hand, they inevitably provide a source of amusement for their mak-

ers. Smiles or bursts of laughter, for instance, always punctuate Frank Afra's detailed descriptions of the parts he uses in his works. He says, "The eyes are always lug nuts [laughing], which go in wheels." Referring to the material component he used to fashion an earring for one of his prizefighters, Frank laughingly reported, "That's a piece of *transmission seal*."

Repairmen sometimes purposely create visual jokes as a means of further exploiting the humorous potential of muffler art. Wordplay is a favorite form of humor. A sculpture displayed at Bootheel Muffler in Caruthersville, Missouri, comically references both the type of work carried out at the shop and the physical effects it has on workers (Brassieur and Bailey 1995: 28–29). Dressed in a snappy mechanic's uniform, the

Figure 64. "When Pigs Fly." Mike Hammond. Melody Muffler & Lube Center, Walla Walla, Washington.

Figure 65. "Minnie Pearl." Mike Hammond. Melody Muffler & Lube Center, Walla Walla, Washington.

sculpture holds up a muffler on which the word "exhausting" has been painted. Mike Hammond also loves punning, and a number of his sculptures depict popular adages or puns. The traditional phrase "when pigs fly," for instance, is rendered tangible in the sculpture of a winged pig that he has attached to an art car (fig. 64). Another visual joke decorating his vehicle is a small artwork depicting a gleaming pearl resting inside a shell. Hammond has labeled this creation "Minnie Pearl," wryly referring both to the precious commodity and to the famous star of the Grand Ole Opry (fig. 65). In a similar fashion, several different businesses use the declaration "No muff too tuff" as their shop motto (see fig. 6).

The inversion of social roles and norms—a cross-cultural characteristic of humor—is recurrent in muffler art. While a majority of muffler men are posed waving or have greetings like "Hi" written on them, a few reverse this theme. A statue at Arco Iris Mufflers, for example, has a sticker bearing the words "Eat me" affixed to its torso. Two other sculptures we have encountered have been actually "flipping off" or "giving the bird" to passing traffic. An individual who reported one of these to us thought the subversion of the customary business practice of being polite to customers was hilarious and was particularly amused by the fact that "Have a nice day" was written on the sculpture. In this way, routine formality and the norms of customer-service expectations and etiquette are playfully overturned.

Ribald or risqué in their own fashion are a number of dog sculptures built by Kevin Doyle which turn the "dog is man's best friend" idea upside down. Although Doyle constructs dogs of all sizes and shapes, his favorite form of canine sculpture is one that depicts the dog positioned with one leg raised as if it is urinating (fig. 66). To further set the scene, the sculptures are placed next to poles, cars, muffler people, or anything else that might attract a dog's attention. Concerning people's reactions to the sculptures, Doyle states, "It's the standard mix. Some people just immediately laugh. Some people stare at it for a few minutes, and then they get that gasping look on their face. And it's also placement. If it's just standing in the middle of the driveway, it's not that effective. But if it's up against somebody, like another little muffler guy or against the wall or if you have somebody like my eleven-year-old, Ryan,

with a cup of water giving a little realism to it. You can have more fun with it. The reaction depends on where they're located." Like the obscenely gesturing figures, the peeing dogs playfully invoke potentially sensitive or taboo issues. As with a dirty joke, some think such creations funny while others are offended.

Sculptures of humans also often become the focal points of bawdy humor or sexual innuendo. Mike Hammond once built a muffler man mailbox for a friend who insisted that the work have a penis. However, a female postal carrier was offended by the figure's sexuality and refused to put mail into it. So the metallic organ was removed. As Mike recalls, "It kind of bothered the female mail delivery person, and his girlfriend kind of encouraged him to remove the penis. This guy had his penis removed, and it wasn't Elena Bobbit that did it, it was me." Workers at G & R Mufflers also informed us about a muffler man with a penis that stood in front of another business until a woman came in and complained about it.

Figure 66. Ryan Doyle with the "peeing dalmatian." Kevin Doyle. Mad Hatter Muffler, Hollywood, Florida.

Mike Hammond's muffler woman, "Muffy," became the subject of an ongoing battle over nudity, a debate from which Mike derived much

amusement (fig. 67). He says, "Since she has funnels for bosoms, there was a group of people that kept dressing her. They put a little miniskirt on her and a bra. And then I'd come to work the next day, and they would all be taken off, and there would be a note on her that said, 'I liked her better naked.' And then I'd come to work the

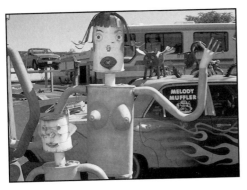

next week and there would be another little shirt or something on her. And that went on for a while. . . . I never did meet the people. . . . One note said that she'd make a good dancing girl. . . . People just got caught up in the humor of the thing itself." In an unexpected re-

verse of the standard discourse on public nudity, one local woman sent him a barrage of letters saying that if "Muffy" was going to be allowed to keep her breasts, then her counterpart, "Muffler Man," should be given a penis. The debate went on and on until Hammond finally wrote to the woman, stating (in a reference to Barbie dolls),"I'll put a penis on him when Ken gets a penis."

Like other forms of jocularity, the various sculptures, whether lewdly gesturing, depicted in scatological poses, or endowed with sexual organs, offer a means of rebelling against constraint. As Mary Douglas points out about humor in general, "[W]hatever the joke, however remote its subject, . . . it is potentially subversive. Since its form consists of the victorious tilting of uncontrol against control, it is the image of the leveling of hierarchy, the triumph of intimacy over formality, of unofficial values over official ones" (1991: 297).

Figure 67. Detail of muffler woman. Mike Hammond. Melody Muffler & Lube Center, Walla Walla, Washington.

CHAPTER 6

AUDIENCE FEEDBACK AND COMMUNITY INTERACTION

As with other types of public display such as yard art, graffiti, and murals, muffler sculptures become memorable features of a built landscape through which individuals move in their day-to-day existence. Because they stand out and capture the attention of viewers (potential customers), muffler sculptures serve as familiar points of reference that are used to formulate and express notions of community and locale. Inhabiting routes that individuals take to work, school, and so on, they are frequently conceived of as intimate neighborhood fixtures. Upon learning that we were documenting muffler sculptures, numerous persons excitedly described or directed us to favorite examples of exhaust art that can be found

in the areas where they live or that they pass while commuting. At shops where the mechanics are constantly building new figures, passersby may find ongoing amusement in the ever-changing line-ups.

Existing as part of a social landscape, muffler statues prompt communicative interaction. They elicit a wide range of reactions in passersby, including the desire to own or construct one, critical evaluations, imaginative contemplation, and innovative ideas (Greenfield 1984: 11). Smiles, laughter, and the honking of auto-mobile horns are the most common responses to muffler sculptures. Some individuals playfully interact with the creations by greeting them as they would another human, shaking their metallic hands or patting them on their heads. Says Wayne Wright of Carson Muffler in Carson, California, "Everybody has to touch it. . . . I've seen grown men come by here [mimes shaking hand], 'How's it going, buddy.'" People sometimes stop at the shops in order to have their portraits taken with the statues: at Affordable Muffler they act like they're boxing with sculptures of prizefighters, while at Melody Muffler and Lube Center they pretend they're being chewed up by the muffler dinosaur. As Kevin Doyle notes, "A lot of times on weekends [people stop] . . . depending on the direction [they] are coming from in the area. If they're on the way to the airport . . . we're like right off of a main drag that would take you to the air-port . . . and we've had people that you could see them. They're in a rented vehicle. You see them make a U-turn on the street. They'll pull in for a second. Get out. Get cameras. Stand next to stuff. Take a few pictures. Get back in the car. And you know they're on the way to the airport."

In some cases, individuals who have taken the photographs later send copies to employees at the shops. Muffler art is especially popular with children. Frank Afra stated that youths enrolled in a Head Start program located next door to his shop often played with his sculptures. Other repairmen point out that they enjoyed the sculptures themselves as children and seem amused when the kids in the neighborhoods where they work are drawn to the figures.

The artworks often serve as points of departure for conversa-tions with neighbors, customers, and others. People stopped by Frank Afra's shop on an almost daily basis to talk with him about

his creations. He says, "I got lots of compliments. People were impressed. Everybody asks me the same questions. 'Where did you get your material, which car did this come from?'" Shop customers or other individuals try to join in the creation, decoration, and display of muffler sculptures by making practical or imaginative suggestions. After watching Gary Koppenhaver laboriously drag one particular muffler sculpture out in front of his shop each morning, a neighbor gave him a wheeled cart to use so that he wouldn't have to work so hard putting out the statue. Gary remembers, "He saw me walking it out every day [and said], 'Hey, I got something for you.'" Discussing the time he and Gary were crafting their first muffler woman, Duncan Turrentine says, "Everybody else that came in had ideas, you had to tune them out."

Often, however, muffler artists are inspired by the reactions and suggestions of customers or passersby. After fashioning a sculpture of a snake, Kevin Doyle placed it outside his shop. One day a little girl passed by the sculpture while on the way to a nearby market with her family. The girl's response to the snake gave Doyle an idea for a new work (plates 22, 23). Describing he events, he says, "And she's looking at it and looking at it. And then she taps her sister on the arm and she starts motioning like a snake charmer like in Aladdin, going up and down and wiggling her fingers and like making the snake dance for her. 'What a great idea.' So the next day I made the snake charmer. And when I saw the little girl, I flagged her down and thanked her. She had some input. I said, 'What's next?' She said, 'How about a big rabbit?' And that was right about Easter time when that came out. So that's where the rabbit came from." Thus, by observing and responding to audience feedback, Doyle not only came up with a new idea for a sculpture, but he also began to solicit suggestions for additional works that would be particularly meaningful to members of his audience.

Given the amount of time and energy that repairmen put into the fabrication of the works and the wonder they excite, it is not surprising that people frequently offer to purchase them. The sale of figures is not uncommon, and, in recent years, the sculptures have become an increasingly popular genre of collectible folk art. Despite growing commercial interest in their creations, many muffler repairmen do not think of their sculptures as commodities to be

bought and sold. They are frequently amused by the notion of producing statues for sale, as it is generally more lucrative to concentrate on replacing damaged mufflers. Offers to purchase the sculptures may be met with a wide range of reactions, including amazement, cautious enthusiasm, or outright refusal. Although he has sold a few figures, Gary Koppenhaver is hesitant to part with sculptures into which he has put so much time and effort. Kevin Doyle was likewise initially somewhat reluctant to part with his creations: "The first one that I can recall was some lady that came in driving a new Lexus obviously not needing a muffler and looked around and she said pleasantly, 'How much for the giraffe?' I said, 'It's not for sale.' She said, 'Oh, of course they are.' 'No. No. I'm not selling them. They're just for the front of the shop. They're decoration.' So she said, 'Well, they've got to be for sale.' I said, 'No.' And I laughed it off and laughed it off. Then somebody else came in and asked the same thing. Kind of halfheartedly wanting to know if I wanted to sell one. 'No.' And then some guy came in who had a sheet metal business and said, 'I need that dog.' It was a three-legged dog. A dog relieving himself on the muffler guy out front. He said, 'I gotta have that dog.' I said, 'The dog's not for sale.' He said, 'I'll give you two hundred bucks if you make me one.' So, I made him a dog."

Kal Mekkawi of Affordable Muffler and Auto Repair was similarly surprised by people's attempts to purchase sculptures. He notes, "I never thought we would be able to sell them. And I was amazed at the money we were offered. The whole idea was to put funny things outside to get people's attention. . . . And we never thought we were going to get money for them. And when they got money, we were like, 'Yeah, okay.'"

As commercial interest in muffler sculptures has increased, workers at some automotive shops have become so adroit at producing and selling works that they have practically established cottage industries. Frank Afra claims to have sold more than seventy sculptures simply by placing them in front of his shop. Regarding his sales, Frank said, "We had lots, but, you see, we never thought it would be so rewarding. I mean financially, it was okay. It's good pocket money. But it just mushroomed." Kevin Doyle and Mike Hammond have each sold more than one hundred works. The

individuals who purchased these figures have placed them in front of their own businesses and in art galleries, offices, and private homes (figs. 68, 69, 70). The sale and display of pieces has become a source of artistic gratification for some muffler artists. Mike Hammond, for instance, is proud that his artwork is featured in front of a number of local businesses such as the Walla Walla Worm Ranch. When we told Frank Afra that several of the works he had sold to a passerby were displayed in a local art gallery, he smiled triumphantly and said, "I finally made it into a museum!" In addition to selling their work, some repairmen, Mike Hammond and Kevin Doyle most notably, have donated sculptures to local charities, schools, and benevolent associations either for use as decorations or as items to be auctioned off for profit.

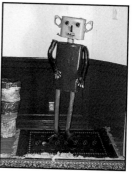

As Sojin Kim argues, vernacular landscapes "reflect not the efforts and visions of one community, but the multiple, sometimes discordant, participation of several" (1997: 11). Accordingly, muffler sculptures become targets for mischief makers and vandals. In keeping with the already noted tendency to sexualize the sculptures, one prankster embellished a muffler figure by drawing a vagina on it with Magic Marker (Gilstrap 1997). In some cases, the sculptures or parts of the sculptures may be stolen, as happened with the various military hats Becky Glenn used to decorate her Fourth of July assemblage. Unknown persons have damaged many works. Some figures have been decapitated; others have broken arms or legs. A motorist hit one of Kevin Doyle's sculptures. He recalls, "We left him out one night. Like his virgin night on the open road and a drunk driver cut the corner and flattened him. He kind of looked like the scarecrow in *Wizard of Oz*. 'They took my legs and

Figure 68. Muffler sculpture used to decorate private home, Los Angeles, California. Work by Salvador Flores and Yasir Flores. La Tortuga Auto Repair, Los Angeles, California.

Figure 69. Muffler mailbox. Mike Hammond. Melody Muffler & Lube Center, Walla Walla, Washington.

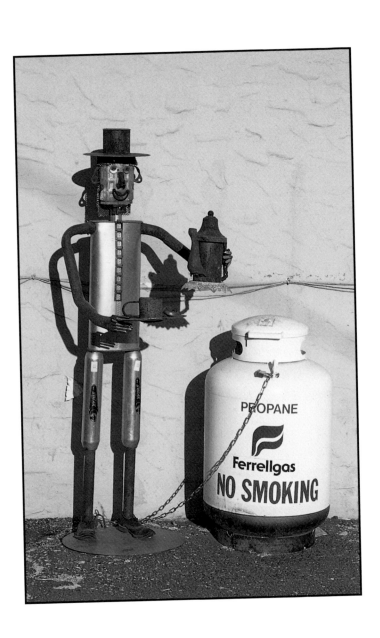

they threw them over there. They took my head and they. . . . ' He was scattered everywhere. And the guy was fairly relieved. He was a drunk driver, he thought he hit a real person." Several artists have suggested that rowdy teenage boys are most frequently the ones responsible for the disfigurement or destruction of artworks.

Sculptures that are left outside for extended periods of time may be stolen, an act that some artists seem to take in stride. The custom of marauding fans defacing icons that represent rival sporting teams has taken its toll on muffler statues. Tom Gannon of Phoenix, Arizona, for instance, once placed a Phoenix Suns jersey on one of his creations in order to cheer on the local professional basketball team. But, as Gannon notes, "Somebody came by and roped him, tied him up, and pulled him away" (Gilstrap 1997). A similar fate befell a figure that Becky Glenn had dressed up in the cheerleading uniform of the local high school team. In the week leading up to a football game with a rival school, the figure disappeared. Becky remarked, "I was hoping to get a postcard from her at least. You know that flamingo that was stolen in Atlanta and then people got postcards from the Grand Canyon and all" (Horton 1998). Likewise, someone actually walked off with the giant "metalsauraus" that is displayed at Melody Muffler and Lube Center. As Mike Hammond notes, "The dinosaur was stolen at one time, and the local newspaper wrote an article trying to find it. And a reward. And it is big enough that it took at least six good-size men to pick it up and haul it away. And it was found out at the local church [laughing] . . . the front yard of the local church. Yeah, it was just a prank." Although damage and environmental wear are generally considered unavoidable, many muffler artists do take precautions to insure against the loss of a statue through theft. Some are placed on roofs or poles, making them inaccessible; others are chained or welded to fences, gates, or poles so that they cannot be removed without great difficulty.

Figure 70. Muffler man pouring coffee at Pangea, a local restaurant. Mike Hammond. Melody Muffler & Lube Center, Walla Walla, Washington.

Positive community feedback can play a crucial role in an artist's decision regarding whether or not to repair a

damaged sculpture. Repairman Barry Vignali of Ron's Radiator Service and Muffler Masters in Phoenix said, "One time somebody came by and . . . broke one of the legs on the muffler man. This happened on the weekend, and by about Wednesday I get a phone call from a little boy about ten or twelve. He says, 'Is this the muffler shop with the muffler man?' I say, 'Yeah, it is.' He says, 'I go by there every day, and I haven't seen him.' I said, 'I tell you the truth, something happened to him. He fell down and got a broken leg.' He said, 'Are you going to fix him?' I said, 'If you want him back up, I'll fix him.' So I did it that afternoon" (Gilstrap 1997).

Despite the threat of vandalism and theft, the makers of muffler sculptures doggedly persist in efforts to keep their works displayed in public space. As Francis Mohsen declares, "If they steal it, I'll make another." Wayne Wright remarked similarly, "If they tag them up, I'll just spray-paint over it."

Muffler sculptures may come under attack from more official sources as well. In some cities, where the municipal regulations concerning the size and type of advertisements that can be mounted in front of a business are quite extensive and are strictly enforced, muffler signage can become the subject of contention. Several muffler sculptors who had been harassed by representatives of the city in the past were, in fact, initially suspicious of our queries, because they thought we worked for the city government. They reported that they had to limit the number of sculptures on display at their shops or were even forced to remove some to comply with local ordinances. The tribulations that Kevin Doyle suffered at the hands of department of transportation officials were even chronicled in a local paper. The manager of Mufflers "El Carnal" reports that he was once hassled by a city official who told him that the muffler sculptures in front of his shop would have to be moved. With a hint of satisfaction in his voice, he quickly added that, since no specific city ordinance was being violated, the man "couldn't really do anything about them."

Stories about both positive and negative community responses to muffler sculptures have become part of the narrative repertoire of individuals who work in proximity to the sculptures on a daily basis. Events that occur as a result of the presence of the artworks are related to coworkers, family members, friends, and others. In

this sense, the pieces become "storage symbols"(Musello 1992: 47). As Musello notes, an item may function, in part, as mnemonic device that serves as an "adjunct to storytelling. . . . [T]he history it encodes . . . is retained in memory and released through the talk the object occasions or facilitates" (1992: 48–49). Mike Hammond, for instance, often refers to the running battle he had with the local woman who objected to the breasts on his female sculpture. He even has a notebook labeled "Letter and Response about Muffler Art, To Be Read by Adults Only, May Be Offensive," which contains the outrageous letters he exchanged with her and which he uses as a storytelling prop.

Most repairmen have favorite stories about their sculptures that they enjoy telling to others. Gary Koppenhaver frequently recounts incidents involving his muffler dog and real canines. He says, "We had a dog sitting out here one time, a guy was walking down the street with his Rottweiler, a big dog. And the dog came walking by and he tells him to get him. And this dog will actually come up and bite the throat on that little metal dog out there [laughter]. An old lady came by here one day walking her dog, the dog took a second take,

Figure 71. Kevin Doyle creating a sculpture during Career Day at a local elementary school, Hollywood, Florida.

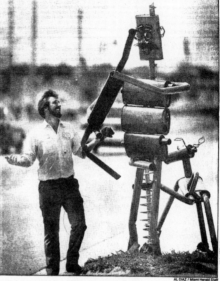

The Miami Herald
FRIDAY, JUNE 16, 1989

DOT bureaucrats cold to charms of Muffler Man

CARL HIAASEN
COLUMNIST

The long arm of the law has caught up with Fred the Muffler Man.

Fred waves from a curb on the 100 block off Northwest Seventh Avenue. He stands 8½ feet tall and is made of four automobile mufflers, plus lots of old exhaust pipe for legs and arms. His eyeglasses are stylishly fashioned from flanges.

He is a creation of Kevin Doyle, manager of the Mad Hatter Muffler Shop. Doyle has been welding odd things out of mufflers since 1981, when he opened the business. He

Muffler Man can't charm bureaucrats

has made a snake, a horse, a rocket, a giraffe, even a mufflerized moose (currently having its rusted antlers replaced).

When Doyle finishes a piece, he puts it outside to amuse passing motorists. "We get people laughing," he says, "they see these stupid old things."

Fred the Muffler Man is a landmark along Seventh Avenue. So is his red dog, another tailpipe-and-muffler invention. The dog can be seen lifting its leg on an imaginary fire hydrant. Kids love it. Rush-hour commuters chuckle and wave. Bus drivers honk.

The Department of Transportation, however, is not amused. A DOT man with a Polaroid camera came to Kevin's muffler shop June 6. A nice fellow, just doing his job. He took pictures of Fred the Muffler Man, of the dog, and of a cheerful hitchhiker also made of muffler parts.

Then the DOT man stuck bright orange stickers on the sculptures. "What in the world are you doing?" asked Kevin Doyle.

The DOT man said Doyle's muffler creations violated Chapter 337.406 of the state code. He said Fred was an advertising device that obstructed the state right of way.

The right of way in question is a patch of weeds that measures roughly 8½ feet by 3½ feet. "Crabgrass," Doyle says. He was amazed that the DOT didn't have anything better to do, what with the emergency budget shortfall in Tallahassee, the turnpike mess, the shortage of toll-takers. "It's goofy to pick on something like this," he says.

Doyle asked if there was anything he could do to save his spot for Fred and the other sculptures. He offered to buy or lease the scraggly patch of alleged crabgrass. The DOT said no.

George Fisher, a supervisor with the agency, says the issue with Fred the Muffler Man is highway safety. "Picture, if you will, losing control of your car and hitting it."

Fisher has a point — although crashing into Fred the Muffler Man wouldn't seem nearly as dangerous as crashing into any one of the giant concrete light poles erected in the right of way along Seventh Avenue. (Years ago a hit-and-run drunk driver ran over an earlier incarnation of Fred, scattering metal limbs everywhere. When Doyle located the culprit and told him what happened, the man said, "Thank God. I thought I'd hit a real person." Then he offered to help put Fred back together.)

Doyle says no merchants or motorists have complained about his unusual sculptures. He is active in the Greater Seventh Avenue Improvement Association, which is trying to spruce up a thoroughfare not known for its scenic beauty. Occasionally people offer to buy one of Doyle's muffler creations, only to find that they aren't for sale. People from Coconut Grove, he says, seem particularly impressed.

Despite local support, Doyle thinks he'll probably have to uproot Fred, the dog and the hitchhiker and move them away from the road. The DOT gave him 10 days to comply or face a $75 fine. The deadline was to

ROADSIDE SCULPTURES: Kevin Doyle, creator of Fred the Muffler Man and his dog, far right, calls the DOT's concern over the sculptures 'goofy.'
AL DIAZ / Miami Herald Staff

expire today. It's but a small consolation that a rain shower has washed off the orange warning stickers.

Doyle's partner, Pete Lynn, has offered to chain himself to Fred as a gesture of protest. "It's more art than advertising," he insists. Says the DOT's Fisher: "It's a commercial advertising work of art, if you will."

Kevin Doyle worries that the state will also make him take down the sign that a customer painted to honor the muffler sculptures. It says: "7th Avenue's Only Tourist Attraction."

News Prints 920-1212

started barking at it. She had to hold it back. And she's just laughing. 'Man,' I said, 'I wish I had a movie camera for this stuff.'" Gary has shared these experiences with a number of other individuals over the years, particularly customers who ask about the muffler dog. He notes that it is "kinda a little story, you know, 'One day when this dog came by. . . . ' They get a kick out of it."

Sometimes the artists integrate their works into various community events and celebrations. Kevin Doyle, for instance, has brought sculptures to several grade schools on Career Day and has even made new figures as the schoolchildren watched (fig. 71). Doyle also spray-painted a number of his figures green, loaded them up on a float, and paraded them along with his family during the local Saint

Figure 72. Newspaper article with picture of Kevin Doyle and one of his muffler sculptures. Reprinted with permission from the Miami Herald, June 16, 1989.

Patrick's Day celebration. Similarly, Mike Hammond has driven his muffler art car as well as a flatbed truck containing various figures in numerous local holiday processions. Describing one event, he says, "The muffler band I have with the organ player, the sax player, the guitar player, and the drummer, we put them in a flatbed with a PA system on it. And one of my bands did a jingle for my business, because I'm also a musician. And we'd play that jingle, the muffler shop jingle, as we went through the parade, and they'd think the band was doing it—as if the muffler band was doing it. And that was kind of interactive with the crowd and they liked that." Reconceived as mobile forms of public art, the sculptures add new levels of meaning to the exhaust repairmen's occupational identities, self-images, and communal attitudes.

Some muffler sculptures have become so popular as artistic or cultural points of interest that they have been praised as "landmarks," "roadside attractions," or examples of "local color" (plate 24). As Mike Hammond notes, "I had no idea that there would be the response that there has been and that it would be a large benefit to my business as well. Not only is it a landmark—people refer to it as a landmark: 'the business next to the muffler shop that has all that stuff'—the news media has picked it up; the local newspaper has written articles about it. People bring people down and take pictures. We're on one of the main highways so a lot of the people just traveling through stop and introduce themselves: 'Well, I'm from Missouri,' or wherever, and then they say, 'Can we have our pictures taken with them?' The people in town, I think that when they do need the products I sell at my store, they remember the store because of the unusual figurines that are out there."

Whether documented in television reports, newspaper articles, or, more recently, on the Internet, the sculptures are presented as visible markers of both individual ingenuity and community identity (fig. 72). News stories make reference to narratives of provenance or have even playfully created fantasies about the sculptures. One article about Gary Koppenhaver and Duncan Turrentine contains a fictional account of how the sculptures came to life and became involved in a series of amazing adventures in Lake Elsinore, with the rocket man, for example, using his jet pack to lead the local baseball team to victory.

The social interaction evoked by muffler sculptures—the recognition and affirmative feedback and resulting gratification—is an integral aspect of the tradition and has been repeatedly referred to by the muffler sculptors we have interviewed. In general, the first sculpture made by a muffler artist is conceived of as a practical, albeit creative, form of advertisement. However, community recognition, the possibility of financial gain, and changing notions of identity frequently lead to the production of additional works. Gary Koppenhaver states, "I make them for fun. . . . It's neat that people really enjoy them. Because to us, at the start, they were nothing. They were advertisement." Of his identity in the town where he lives and works, Koppenhaver declares that everyone calls him "the muffler man." Buoyed by the local recognition he and Duncan have received, Gary vows, "We're going to make something just for the town to look at. . . . I'd like to do a whole bunch of them. Just for people [to say], 'Hey, have you seen this guy's shop, fifty muffler men standing out in front.' Eventually, that's what I'd like to do, if I'm still here, just for fun."

CONCLUSION

The traditional practice of crafting muffler sculptures, one that finds expression in an occupational and urban setting, exemplifies the human creative impulse to aesthetically enrich the work environment and endow it with meaning. As we have seen, statues placed outside automotive repair shops may take on a multiplicity of meanings based upon any number of idiosyncratic factors associated with the processes of design, construction, and display. As an occupational signage tradition, muffler art allows individuals to personalize workspace and communicate socially through a unique self-crafted form of artistic expression. These works are more than mere advertisement; they are mascots that proclaim individual identity and group membership. Individual predilections, personal experiences, and face-to-face interactions inform and are constructed around these sculptures, serving to imbue them with esoteric and symbolic significance.

The crafting of muffler art presents challenges that evoke and evince imaginative creativity, innovation, and skill, resulting in satisfaction with completed works. Designing and assembling sculptures alters the cognitive processes through which individuals discern their work materials and the skills and tools of their vocation. The making of such art involves a "continuous shifting of consciousness

stimulated (from within and without) through haptic visual percep-
tion, conceptualizing, reverie, human interaction, or a combination
of these and other factors" (Greenfield 1984: 9). The creative process
calls forth memories and emotions which are then imbedded in the
figures. Gary Koppenhaver sums this up well when he notes, "
'Cause really that's us making that, mind-wise and feeling-wise."

Muffler art is meant to provoke reactions. Passersby and cus-
tomers honk, compliment the works, make suggestions concerning
them, query their makers about materials and inspiration/prove-
nance, pose for pictures, and, perhaps most important, stop to have
their mufflers repaired. There is a recognition of universals in the re-
sponse to the sculptures as playfully transforming the ordinary into
something extraordinary, whether it be the inanimate brought to
life in vaguely human-like figures—caricatures of self, colleagues,
and friends—or as culturally significant and recognizable characters
such as Santa Claus, the Pink Panther, boxers, and cowboys. The
communicative acts evoked by these artworks build self-esteem
and create a sense of emotional connectedness, both among
coworkers and between the sculptors and the local communities in
which they work (Jones 1995: 265). The social interaction that oc-
curs during construction and subsequently as people respond to the
sculptures serves to layer them with multiple levels of significance.
Inscribed by events through time, the figures become "nostalgic
embodiments"(Jones 1995: 260) of a range of associations and
reminiscences for artists and audiences alike.

Like other forms of folk art, muffler sculptures are used to con-
struct or "reconstruct one's sense of identity and relationship to
others, to place, and to the past" (Jones 1995: 267). Such artistic
creation is both "self forming and transforming" (Greenfield 1984:
7). As Sojin Kim argues, "People create their physical surroundings
not simply in the structures they build or adorn. They also shape
and give spaces meaning through the ways they interact and use
them"(1997: 13). All around us the environment is dynamically en-
acted through material behavior. Muffler sculptures and the socia-
bility they inspire embody this impulse to think and act through
tangible human creations. Referring to the "exhaust art" he has
created and sold, Frank Afra states, "I made a rule for myself: I
won't fall in love. I will fall in love with the idea, but I won't fall in

love with the material thing. . . . I can always make more." Countless Americans—pedestrians and those on their daily commutes by automobile—have fallen in love, if only for a passing moment, with the artworks that Afra and other creative muffler shop workers have made to enliven our roadsides.

REFERENCES

Aldiss, Brian W. 1982. "Robots: Low-Voltage Ontological Currents." In *The Mechanical God: Machines in Science Fiction*, edited by Thomas P. Dunn and Richard D. Erlich. Westport, CT: Greenwood Press.

Apte, Mahadev L. 1985. *Humor and Laughter: An Anthropological Approach*. Ithaca and London: Cornell University Press.

Baeder, John. 1996. *Sign Language: Street Signs as Folk Art*. New York: Harry N. Abrams, Incorporated.

Beattie, James. 1778. *Essays on Poetry and Music, as they Effect the Mind; on Laughter, and Ludicrous Composition; on the Utility of Classical Learning*. Edinburgh: W. Creech; London: E. Dilly.

Bennett, John. 1969. "Folk Speech and Legends of the Trade of Housepainting." *Southern Folklore Quarterly* 33: 313–16.

Brassieur, C. Ray, and Deborah Bailey. 1995. *Art and Heritage of the Missouri Bootheel: A Resource Guide*. Columbia, MO: University of Missouri Museum of Art and Archaeology.

Bronner, Simon J. 1983. "Links to Behavior: An Analysis of Chain Carving." *Kentucky Folklore Record* 29: 72–82.

———. 1986. "Folk Objects." In *Folk Groups and Folklore Genres: An Introduction*, edited by Elliott Oring. Logan, UT: Utah State University Press.

Brunvand, Jan Harold. 1986. *The Study of American Folklore: An Introduction*. New York and London: W. W. Norton and Company.

Cantrell, Brett. 1998. *Roadside Signs*. Etowah, TN: The Tennessee Overhill Heritage Association.

Cerny, Charlene, and Suzanne Seriff, eds. 1996. *Recycled, Re-Seen: Folk Art from the Global Scrap Heap*. New York: Harry N. Abrams in association with the Museum of International Folk Art, Santa Fe.

Correll, Timothy Corrigan, and Patrick Arthur Polk. 1999. "Muffler Men, *Muñecos*, and Other Welded Wonders: Occupational Sculpture from Automotive Debris." In *The Cast-Off Recast: Recycling and the Creative Transformation of Mass-Produced Objects*, edited by Timothy Corrigan Correll and Patrick Arthur Polk. Los Angeles: UCLA Fowler Museum of Cultural History.

Cubbs, Joanne, and Eugene W. Metcalf, Jr. 1996. "Sci-Fi Machines and Bottle-Cap

Kings." In *Recycled, Re-Seen: Folk Art from the Global Scrap Heap*, edited by Charlene Cerny and Suzanne Seriff. New York: Harry N. Abrams in association with the Museum of International Folk Art, Santa Fe.

Dewhurst, C. Kurt. 1984. "Arts of Working: Manipulating the Urban Work Environment." *Western Folklore* 43: 192–202.

———. 1988. "Art at Work: In Pursuit of Aesthetic Solutions." In *Inside Organizations: Understanding the Human Dimension*, edited by Michael Owen Jones, Michael Dane Moore, and Richard Christopher Snyder. Newbury Park, CA: Sage Publications.

Dewhurst, C. Kurt, and Marsha MacDowell. 1980. *Cast in Clay: The Folk Pottery of Grand Ledge, Michigan*. East Lansing, MI: Michigan State University.

Douglas, Mary. 1991. "Jokes." In *Rethinking Popular Culture: Contemporary Perspectives in Cultural Studies*, edited by Chandra Mukerji and Michael Schudson. Los Angeles: University of California Press.

Evans, Timothy. 1998. *King of the Western Saddle: The Sheridan Saddle and the Art of Don King*. Jackson: University Press of Mississippi.

Evans-Pritchard, Deirdre. 1985. "Vehicles for Expression: Two Decorated Cars in Los Angeles." *Folklore and Mythology Studies* 9:1–15.

Gilstrap, Peter. 1997. "In the Valley of the Muffler Men." http://www.phoenixnewtimes.com/1996/082996/screed2.html

Graham, Joe. 1991. "*Hecho a Mano en Tejas.*" In *Hecho en Tejas: Texas-Mexican Folk Arts and Crafts*, edited by Joe Graham. Denton, TX: University of North Texas Press.

Green, Archie. 1999. "Tin Men on Parade." *Labor Heritage* 10, no. 3: 34–47.

Green, Archie, and Phil Airulla. 1996. "'Tin Men'—The Sheet Metal Worker's Human Touch in Metal." *Sheet Metal Workers Journal* 87, no. 1: 4–8.

Greenfield, Verni. 1984. *Making Do or Making Art: A Study of American Recycling*. Ann Arbor, MI: UMI Research Press.

Horton, Laurel. 1998. Personal communication.

Jones, Michael Owen. 1967. "Soda Fountain and Restaurant Calls." *American Speech* 42: 58–64.

———.1989. *Craftsman of the Cumberland: Traditions and Creativity*. Lexington: University Press of Kentucky.

———. 1995. "Why Make (Folk) Art?" *Western Folklore* 54: 253–76.

———. "The Aesethetics of Everyday Life, or What Do Ukrainian Icons and Orange County Bathrooms Have in Common?" Unpublished manuscript.

Keller, Charles, and Janet Dixon Keller. 1993. "Thinking and Acting with Iron." In *Understanding Practice: Perspectives on Activity and Context*, edited by Seth Chaiklin and Jean Lave. New York: Cambridge University Press.

Kim, Sojin. 1997. "Vital Signs: Signage, Graffiti, Murals and 'Sense of Place' in Los Angeles." Ph.D. diss., University of California at Los Angeles.

Kirshenblatt-Gimblett, Barbara. 1989a. "Authoring Lives." *Journal of Folklore Research* 26: 123–50.

———.1989b. "Objects of Memory: Material Culture as Life Review." In *Folk Groups and Folklore Genres: A Reader*, edited by Elliott Oring. Logan, UT: Utah State University Press.

Kitchener, Amy V. 1994. *The Holiday Yards of Florencio Morales: "El Hombre De Las Banderas."* Jackson: University Press of Mississippi.

Larwood, J., and J. C. Hotten. 1866. *History of Signboards, from the Earliest Times to Present Day*. London: Chatto and Windus.

Limón, José. 1994. *Dancing with the Devil: Society and Cultural Poetics in Mexican-American South Texas*. Madison WI: University of Wisconsin Press.

Lockwood. Yvonne R. 1984. "The Joy of Labor." *Western Folklore* 43: 202–11.

McCarl, Robert S. 1974. "The Production Welder: Product, Process and the Industrial Craftsman." *New York Folklore Quarterly* 30: 243–54.

———. 1978. "Occupational Folklife: A Theoretical Hypothesis." *Western Folklore* 37: 145–60.

Meñez, Herminia Q. 1988. "Jeeprox: The Art and Language of Manila's Jeepney Drivers." *Western Folklore* 47: 38–47.

Molecular Expressions: The Silicon Zoo. 1998.
 http//www.micro.magnet.fsu.edu/creatures/index.html

Muffler Men Sightings http://www.roadsideamerica.com/set/muflist.htm

Mullen, Patrick. 1978. *I Heard the Old Fishermen Say: Folklore of the Texas Gulf Coast.* Austin: University of Texas Press.

Musello, Christopher. 1992. "Objects in Process: Material Culture and Communication." *Southern Folklore* 49: 37–60.

Narváez, Peter, and Martin Laba. 1988. "Introduction: The Folklore-Popular Culture Continuum." In *Media Sense: The Folklore-Popular Culture Continuum*, edited by P. Narváez and M. Laba. Bowling Green, OH: Bowling Green University Press.

Neal, Avon. 1969. *Ephemeral Folk Figures.* New York: Clarkson N. Potter, Inc.

Nickerson, Bruce E. 1978. "Ron Thiesse: Industrial Folk Sculpture." *Western Folklore* 37: 128–33.

Oring, Elliott. 1992. *Jokes and Their Relations.* Lexington: University Press of Kentucky.

Ortner, Sherry. 1973. "On Key Symbols." *American Anthropologist* 75, no. 5: 1338–46.

Pocius, Gerald. 1995. "Art." *Journal of American Folklore* 108: 413–31.

Richardson, Miles. 1974. "Images, Objects, and the Human Story." In *The Human Mirror: Material and Spacial Images of Man*, edited by Miles Richardson. Baton Rouge: Louisiana State University Press.

Roy, Donald F. 1959–60. "'Banana Time': Job Satisfaction and Informal Interaction." *Human Organization* 18: 158–68.

Santino, Jack. 1978. "The Characteristics of Occupational Narrative." *Western Folklore* 37: 199–212.

Smith, Virginia. 1993. *The Funny Little Man: The Biography of a Graphic Image.* New York: Van Nostrand Reinhold.

Stableford, Brian M. 1987. *The Sociology of Science Fiction.* San Bernardino, CA: The Borgo Press.

Tangherlini, Timothy R. 1998. *Talking Trauma.* Jackson: University Press of Mississippi.

Taylor, Lonn, and Ingrid Maar. 1983. *The American Cowboy.* New York: Harper & Row.

Turner, Kay. 1996. "Hacer Cosas: Recycled Arts and the Making of Identity in Texas-Mexican Culture." In *Recycled, Re-Seen: Folk Art from the Global Scrap Heap*, edited by Charlene Cerny and Suzanne Seriff. New York: Harry N. Abrams in association with the Museum of International Folk Art, Santa Fe.

Zelinsky, Wilbur. 1994. *Exploring the Beloved Country: Geographic Forays into American Society and Culture.* Iowa City: University of Iowa Press.

Interviews

The interviews for this book took place during the years 1997 to 1999. While we have spoken with scores of repairmen, the most extensive discussions, as evidenced by the content of the book, were with Frank Afra of Affordable Muffler and Auto Repair in Santa Ana, California; Kevin Doyle of Mad Hatter Muffler in Hollywood, Florida; Yasir Flores and Salvador Flores of La Tortuga Auto Repair in Los Angeles; Mike Hammond of Melody Muffler & Lube Center in Walla Walla, Washington; and Gary Koppenhaver and Duncan Turrentine of G & R Muffler in Lake Elsinore, California. The field notes, photographs, and taped interviews used in this book reside in the Folklore Archives at the University of California, Los Angeles.

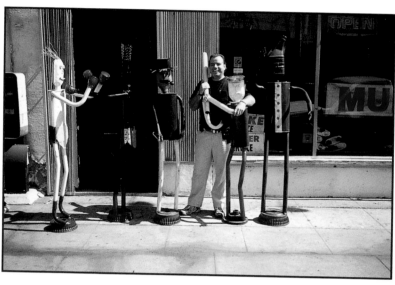

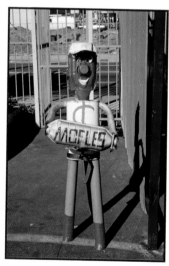

Plate 1. Frank Afra with muffler sculptures. Affordable Muffler and Auto Repair, Los Angeles, California.

Plate 2. Muffler man. Isidro Hernandez. Azteca Tire and Muffler, Los Angeles, California.

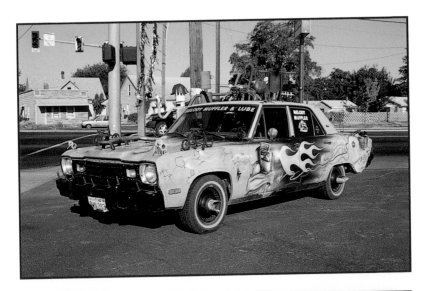

Plate 3. Mike Hammond's "art car." Melody Muffler & Lube Center, Walla Walla, Washington.

Plate 4. Detail of art car. Iguana wearing a hat. Melody Muffler & Lube Center, Walla Walla, Washington. In his spare time, Mike Hammond plays drums in a local rock band named Iguana Hat.

Plate 5. Detail of art car. Spider and spider web. Melody Muffler & Lube Center, Walla Walla, Washington.

Plate 6. Detail of muffler man's face. Rodolfo Portillo and Sal Martinez. Hot Shot Muffler, Los Angeles, California.

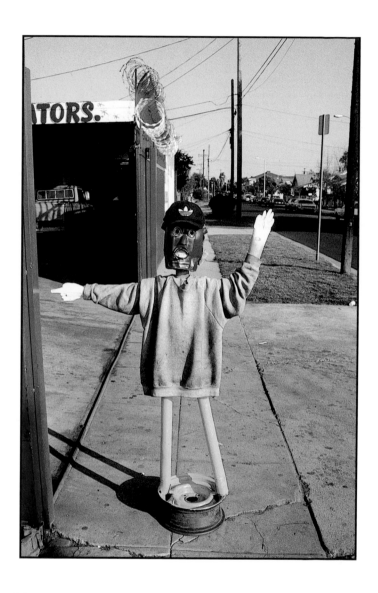

Plate 7. Wearing cast-off
clothes, this muffler man
waves to potential customers.
Isidro Hernandez. Azteca Tire
and Muffler, Los Angeles,
California.

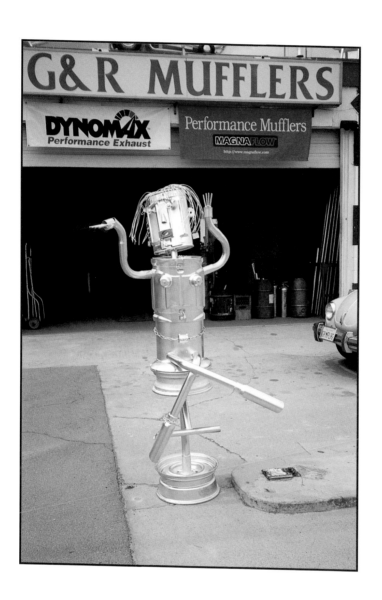

Plate 8. "Harley-Davidson Biker Babe." Gary Koppenhaver and Duncan Turrentine. G & R Mufflers, Lake Elsinore, California.

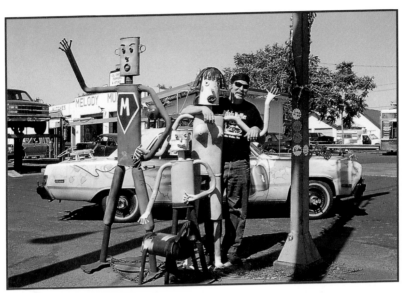

Plate 9. Muffler family. Mike Hammond. Melody Muffler & Lube Center, Walla Walla, Washington.

Plate 10. Bee. Mike Hammond. Melody Muffler & Lube Center, Walla Walla, Washington.

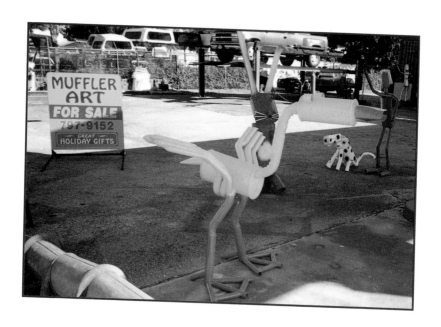

Plate 11. Duck. Kevin Doyle.
Mad Hatter Muffler,
Hollywood, Florida.

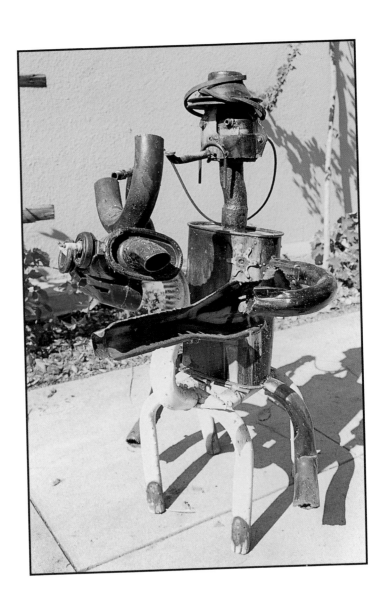

Plate 12. <u>Vaquero</u> (cowboy).
Victor Lopez. Lincoln Auto
Repair and Muffler, Santa
Monica, California.

Plate 13. Cheerleader and muffler hound. Glenn's Muffler Shop, Seneca, South Carolina.

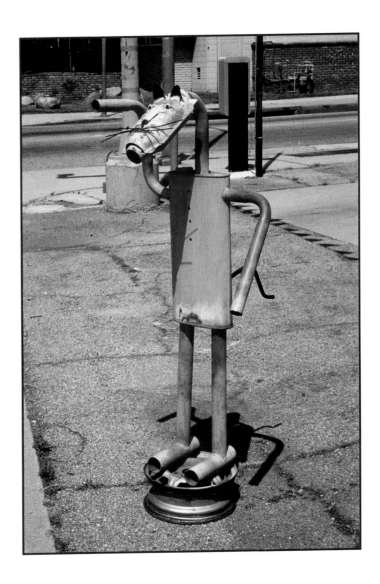

Plate 14. Pink Panther.
Enrique Siru. Henry's Muffler
Shop, Pasadena, California.

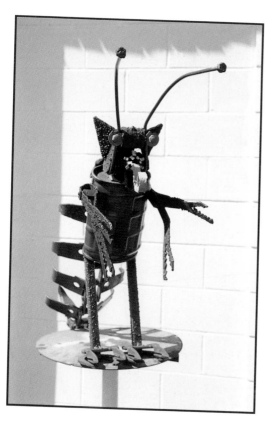

Plate 15. Gargoyle. Mike Hammond. Melody Muffler & Lube Center, Walla Walla, Washington.

Plate 16. Devil. Jessie Tarula. Azteca Tire and Muffler, Los Angeles, California.

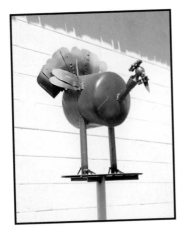

Plate 17. Thanksgiving turkey. Mike Hammond. Melody Muffler & Lube Center, Walla Walla, Washington.

Plate 18. Santa Claus. Kevin Doyle. Mad Hatter Muffler, Hollywood, Florida.

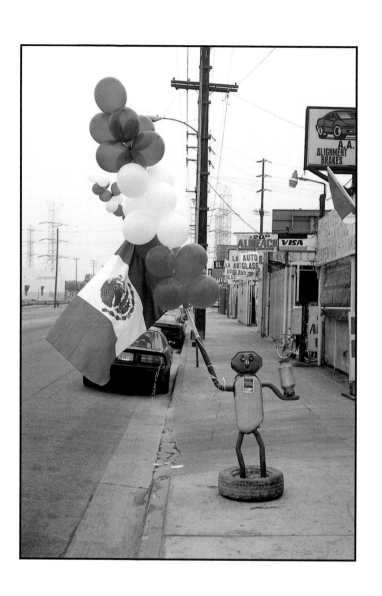

Plate 19. Muffler man with Mexican flag added in celebration of the feast day of the Virgin of Guadalupe. Miguel Gutierrez. AAA Mufflers and Radiators, Los Angeles, California.

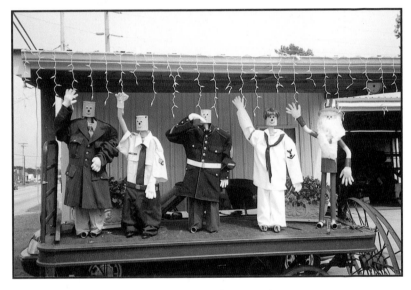

Plate 20. "Irish Muffler Hound." Kevin Doyle. Mad Hatter Muffler, Hollywood, Florida.

Plate 21. Fourth of July display featuring muffler servicemen. Glenn's Muffler Shop, Seneca, South Carolina.